D1308195

The Artist in Society

Selected essays from the conference
"The Artist in Society: *Rights, Roles, and Responsibilities*"

October 13-15, 1994
The School of the Art Institute of Chicago

The Art Institute of Chicago,
Department of Museum Education

The **Artist** in Society:

Rights, Roles, and Responsibilities

edited by Carol Becker and Ann Wiens

Kathy Acker

Carol Becker

Homi K. Bhabha

Michael Brenson

Page duBois

Michael Eric Dyson

Henry A. Giroux

Chicago New Art Association
New Art Examiner Press
Chicago

First published 1995 in the USA by
New Art Examiner Press
314 W. Institute Place
Chicago, IL 60610

Library of Congress Catalogue Card Number: 95-70748

ISBN 0-9647855-0-1

Printed and bound in the United States of America

To the memory of Barney Simon (1932-1995), one of South
Africa's most internationally acclaimed directors and playwrights,
co-founder of the Market Theater, a man of unending courage
and vision who brought integrated casts and audiences to
apartheid South Africa.

Contents

Introduction

In the spring of 1994 my edited anthology *The Subversive Imagination: Artists, Society, and Social Responsibility* was published by Routledge. It was an effort in which I had been engaged for several years and represented the work of 15 writers, artists, and intellectuals from two hemispheres whose contributions attempted to place the artist in a broad historical context. In October 1994, thanks to a generous grant from the John D. and Catherine T. MacArthur Foundation, Ronne Hartfield, Director of Museum Education at The Art Institute of Chicago, and I were able to bring most of these writers and artists, along with several additional participants, to the Art Institute of Chicago for a three-day conference, which continued the discussion under the new heading: "The Artist in Society: Rights, Roles, and Responsibilities."

Working with Nick Rabkin, we envisioned an ambitious seminar for the city of Chicago. We invited Carlos Fuentes to be the keynote speaker, and more than 1200 people attended his address: "Imagination and Historical Change." For the two days that followed, almost as many came to hear the panels and to attend discussion sessions with some of the most thoughtful people working within Chicago's many art worlds.

There were four panels, held in sequence: "The Artist as an Historical Construct," "The Artist in Transition: Eastern Europe, Iran, Mexico, and South Africa," "The Artist/Intellectual in a Postcolonial World," and "On the Edge of the Future: Survival of the Artist in the New Political Climate." Participating in these panels were many whose writings were included in *The Subversive Imagination*: Kathy Acker, Page duBois, Michael Dyson, Henry Giroux, Martha Rosler, Felipe Ehrenberg, Ewa Kuryluk, Njabulo Ndebele, Ahmad Sadri, Coco Fusco, and B. Ruby Rich. Other culture critics and cultural workers invited to participate in the conference included Michael Brenson, Arjun Appadurai, Pavel Buchler, Chris Bratton, Lisa Brock, Andries Botha, and Marilyn Martin. (Elizam Escobar and Guillermo Gómez Peña, who had both written for the book, could not attend: Escobar because he was and still is a political prisoner in an Oklahoma jail, and Gómez Peña because he was involved in a major performance at the Detroit Museum.) Ronne Hartfield and I each chaired panels and delivered speeches.

Perhaps most significant to the spirit of the conference was that registration and all events were free and open to the public. This allowed high-school teachers as well as college professors from around the city and the state to bring their classes to Fuentes's keynote address and to the many panels. Groups attended from various arts organizations. After the event, we received a great deal of correspondence offering responses to the conference and informing us that discussion of the issues debated in October 1994 continued in various study groups that had formed as a result of the symposium.

Several participants in the conference wrote new papers for the event, further extending the ideas represented in *The Subversive Imagination*. Seven of those are presented here. We hope that this collection of essays will encourage the debate and discussion sparked by the book and the conference.

This special publication is the result of a collaboration between the *New Art Examiner*, The John D. and Catherine T. MacArthur Foundation, and The School of the Art Institute of Chicago. *New Art Examiner* Editor Ann Wiens and I would like to thank the following individuals for all their contributions of time and talent to this project: Ronne Hartfield, my Co-Chair for the conference; Paul Pribbenow and Paul Elitzik from The School of the Art Institute of Chicago; the *New Art Examiner* staff: Deborah Wilk, Kathryn Hixson, Jennifer Riddell, Guido Mendez, María José Barandiarán, Melissa Bargar-Hughes, Heather Jones Gay, and Jason Greenberg; Laura Mosquera; Dan Danzig; and everyone else who worked to make this publication possible.

As public funding for the arts becomes frighteningly scarce, artists and educators will need to fight that much harder to create innovative and intellectual debate for a large audience. We will also increasingly have to look to private philanthropy to bring such events into existence. We would all like to thank Nick Rabkin and the MacArthur Foundation once again for their help in making this publication possible, for their ongoing faith in the art communities of Chicago, and for their encouragement and support of the open forums that are essential to a healthy democracy.

Carol Becker
Chicago, July 1995

Borderline Artists,
Cultural Workers,
and the Crisis of Democracy

Henry A. Giroux

Within the last decade, *artists have been*

caught in an ideological whirlwind regarding the role they

play in their appeal to a wider public.

I want to insert a broader notion of the political back into this argument, not merely as a way to counter right-wing dema- goguery, but also as part of an attempt to rearticulate the role of artists as cultural workers whose public function offers them the opportunity to serve as border intellectuals who engage in a productive dialogue across different sites of cultural produc- tion. Border intellectuals function in the space between "high" and popular culture; between the institution and the street; between the public and the private. Invention, specificity, and critique mark the space of the border as partial, fluid, and open to the incessant tensions and contradiction that inform one's identity, struggles, and relationship to the world. At stake here is not merely the opportunity to link art to practices that are transgressive and oppositional, but also to make visible a wider project of connecting forms of cultural production to the cre- ation of multiple critical public spheres.[1]

Of course, such connections need not be amplified in exclu- sive, theoretical terms. Changing historical conditions often re- define and produce discourses articulating how multiple con- structions of agency are figured within new forms of self-repre- sentation and collective struggle. It is within the tension between what might be called the trauma of identity formation and the demands of public life that cultural work is both theorized and made performative. Homi K. Bhabha has amplified this point by arguing that cultural work and theory generally emerge in the face of a problem, and that theory "should go beyond illuminat- ing the deep structure of an event, object, or text, should do more than establish or embellish the framing discourse within which this object of analysis is placed. What theory does first of all is respond to a problem."[2] Public life, the act of theorizing, and cultural production cannot be abstracted from the conditions that we inherit, inhabit, mediate, challenge, and transform.

To make this point more concrete, I want to begin with some brief biographical remarks that hopefully will illuminate, in part, some important moments in my own formation as an educator and cultural worker. I then want to highlight why I

think it is imperative that any discourse about the role of artists and other cultural workers in society should be seen as part of a larger project organized around the relationship between the notion of insurgent cultural politics and what I call the recapturing of public space. Let me begin with the idea of "border" as a referent for demarcating the space between schooling and the broader notion of education.

Growing up in a working-class neighborhood in Providence, Rhode Island provided me with a particular orientation to the relationship between popular culture and schooling. Popular culture was where the action was—it marked out a territory where pleasure, knowledge, and desire circulated in close proximity to the life of the streets. There was always something forbidden about this culture, with its comics, pinball machines, restricted codes, visual excesses, and overly masculine orientation. My friends and I collected and traded comic books, learned about desire through the rock'n'roll of Little Richard and Bill Haley and the Comets, and drank to the blues of Fats Domino. We hated Pat Boone and didn't know the suburbs even existed. We *felt* rather than *knew* what was really useful knowledge. And we talked, danced, and lost ourselves in a street culture that never stopped moving. Then we went to school.

Something stopped us in school. For me, it was like being sent to a strange planet. Teaching was exclusively centered on obscure books and the culture of print. Desire was mainly a male prerogative reserved for sports during recess time. The language we learned and had to speak was different, strange, and unusually verbose. Bodily and intellectual memories disappeared for working-class kids in this school. We were on a different train, one oriented toward a cheap imitation of the knowledge of high culture. Latin, Western civilization, math, spelling, social studies, and religion were given to us through the force-feeding methods that characterized public schools for kids who had little hope of leaving their neighborhood, even if they

graduated. This is not to suggest that we didn't learn anything, but what we learned had little to do with where we came from, who we were, or where, at least, we *thought* we were going. Many of my friends dropped out of school early. Some endured it in order to get a decent job, and some, like myself, were lucky. I played basketball, won a college scholarship, and moved out of my working-class environment.

It took me a long time to respect the culture I left when I went to college. I never romanticized my background, it was much too contradictory and violent for that. I lost my ability to deal with the memories that my background provided because I had become used to thinking that the only route out of my past was to escape into a middle-class world. I was dead wrong, and only in my thirties did I make the journey back—into memories, histories, and old friends—in order to understand the haunting quality of my own sense of homelessness and identity.

My identity had been fashioned largely outside of school. Films, books, journals, videos, and music in different and significant ways did more to shape my politics and life than did my formal schooling, which always seemed to be about somebody else's stories. In my thirties, as a public-school teacher, I sought to insert the political back into schooling, and in doing so attempted to develop a notion of critical pedagogy within the narrow imperatives of public schooling.

In the late '70s, I left public-school teaching and found myself working as a radical educator at Boston University. Primarily attempting to develop and implement the teachings of Paulo Freire, the Brazilian educator, I confined my focus largely to preparing teachers to assume the position of provocateur and to take their role as critical agents seriously. Then my life changed. I got fired by the president of Boston University, John Silber, one of the more renowned right-wing pseudo intellectuals of the '80s, and I realized during the ensuing Reagan-Bush years that what was under assault in this country was not simply the threat to the status quo posed by radical educators and progressive artists. It was really an attempt by conservatives to remove the

language of ethics, history, and community from public discourse, as well as to smother any understanding of how people are related to one another within networks of hierarchy and exploitation. It was an attack on the very notion of the public itself. John Silber and Rush Limbaugh, along with Beavis and Butthead, soon became celebrities, and I no longer defined myself exclusively as a school teacher; I became a cultural worker.

In part, this means that I no longer focus on how knowledge, power, desire, and identity are produced and challenged exclusively within the complex culture of schooling. I now focus on how pedagogy is produced, taken up, distributed, consumed, and resisted in a variety of sites ranging from Benetton's advertising campaigns to Disney's animated films. The key issue here is that *education* cannot be reduced to the discourse of *schooling*. Pedagogical relationships exist wherever knowledge is produced, highlighting how conflicts over meaning, language, and representation become symptomatic of a larger struggle over cultural authority, the role of intellectuals and artists, and the meaning of democratic public life.

If criticism and cultural politics are to recover the space of the artist and other cultural workers as border public intellectuals, then it is imperative that a sense of urgency about constructing diverse critical public spheres be animated by a revitalized notion of pedagogy. In part, this means understanding pedagogy as a deliberate attempt on the part of cultural workers to influence how and what knowledge, identities, and social relations are constructed within varied sites of learning. Reconstituted as a radical cultural politics, pedagogy draws attention to the ways in which knowledge, power, desire, and experience are produced under conditions of exchange, translation, and learning. This approach to pedagogy posits the necessity for cultural workers to revitalize the language of the social and recover the possibility for diverse groups to address particular issues such as racism, sexism, homophobia, and class inequality. Implicit in such a project

is the necessity for artists and other cultural workers to develop a radical cultural politics based on "an invigorated, active idea of [the] public." Similarly, central to a radical cultural politics is the need to rethink how cultural work in the arts, schools, and other sites can be expressed through an "integrative critical language through which values, ethics, and social responsibility"[3] are fundamental to creating shared critical public spaces that engage, translate, and struggle with the vexing social problems that undermine any possibility of creating a radical democracy.

With this qualification in mind, I want to stress that critical pedagogy as a theory and practice does not legitimate a romanticized notion of the cultural worker as one who can only function on the margins of society, nor does it refer to a notion of teaching/performance/cultural production in which formalism or the fetish of method erases the historical, semiotic, and social dimensions of pedagogy as the active construction of responsible and risk-taking citizens. At the same time, to suggest that artists and other cultural workers take a political stand without standing still does not mean that by default they engage in pedagogical or cultural terrorism. Pedagogy or forms of cultural production that aim at informing and changing are rarely as doctrinaire or impositional as their critics claim. Moreover, art, whether without or with a concerted notion of cultural authority or politics, is seldom neutral. The crucial questions are how cultural work is produced, engaged, distributed, and sustained to secure particular forms of authority; under what terms of exclusion and inclusion this takes place; and what interests and social relations are generated.

There is a distinction between cultural/pedagogical work that is *political* and work that is *politicizing*. A political, as distinct from a politicized, form of cultural work would encourage artists, students, and other cultural workers to become insurgent citizens in order to challenge those with political and cultural power as well as to honor the critical traditions within the dominant culture that make such a critique possible and intelligible. Political cultural work means decentering power in the

museum, theater, classroom, and other pedagogical sites. It also addresses and engages the dynamics of those institutional and cultural practices that marginalize some groups, repress particular types of knowledge, and disavow critical dialogue.

On the other hand, politicizing education or cultural work is a form of pedagogical terrorism in which the issue of what is produced, taught, and exhibited; by whom; and under what conditions is determined by a doctrinaire political agenda that refuses to examine its own values, beliefs, and ideological construction. While refusing to recognize the social and historical character of its own claims to history, knowledge, and values, a politicizing education silences dissent in the name of a specious universalism and denounces all transformative practices through an appeal to a timeless notion of truth and beauty. For those who practice a politicizing education, democracy and citizenship become dangerous in that the precondition for their realization demands critical inquiry, the taking of risks, and the responsibility to resist and say no in the face of dominant forms of power.[4]

Pedagogy as a cultural and political practice must become a defining principle for understanding how artists, media workers, social workers, teachers, and others might produce, negotiate, and translate a language shared by cultural workers who work in diverse sites and public spheres. It is crucial that the relevancies informing such cultural work provide a vision and space, a language of critique and possibility, for addressing three issues increasingly central to what the responsibilities defining the role of the artist/cultural worker and critic might be within and across national and transnational terrains.

First, cultural workers need to challenge dominant assumptions regarding what knowledge and social objects are worth studying. Rather than restrict social knowledge to the texts of high culture, cultural workers can expand their analyses to include a range of popular, cultural texts such as movies, street art, video games, and other media texts in order to understand

more clearly how power works through the popular and everyday to produce knowledge, social identities, and diverse maps of desire. Crucial here is the ongoing pedagogical work of understanding how social practices that deploy images, sounds, and other representational matter are redefining the production of knowledge, reason, and new forms of global culture. Cultural workers in most sites are now facing the task of interrogating how technology and science are combining to produce new information systems that transcend local/global and high/low culture dichotomies. Virtual reality systems and the new digital technologies that are revolutionizing media culture will increasingly come under the influence of an instrumental rationality that relegates their use to the forces of the market and passive consumption. Popular culture must be addressed not merely for the opportunities it provides to revolutionize how people learn or become cultural producers, but for the role it will play in guaranteeing human rights and social justice. This suggests the need for a new debate around reason, Enlightenment rationality, technology, and authority.

Second, cultural workers need to take seriously Walter Benjamin's call for intellectuals to assume responsibility for the task of translating theory back into a constructive practice that transforms the everyday terrain of cultural and political power. This suggests not only expanding the range of traditional and non-traditional media as part of the realm of public art, but also meeting the need to produce art/culture/pedagogies that address the crisis of cultural identity that has emerged with the collapse of a public discourse forged in the polarizing determinations and fears of the Cold War. The production of art and cultural work should always be suspicious of its own politics, while simultaneously demanding political and cultural projects tempered by humility, a moral focus on suffering, and a commitment to move beyond the inside/outside divide that separates forms of cultural work. This suggests rejecting both the notion of the cultural worker who speaks as the "universal intellectual," and that of the specific intellectual who speaks exclusively within the sometimes

essentializing claims of identity politics. Cultural politics needs to create those spaces where borderline artists and cultural workers function as border intellectuals.[5] If the universal intellectual speaks for everyone, and the specific intellectual is wedded to serving the narrow interests of distinct cultural and social formations, the border intellectual travels within and across communities of difference, working in collaboration with diverse groups and occupying many sites of resistance while simultaneously defying the specialized, parochial knowledge of the individual specialist, sage, or master ideologue. As border intellectuals, cultural workers can articulate and negotiate different struggles as part of a broader effort to secure social justice, economic equality, and human rights within and across regional, national, and global spheres.

Third, while the politics of identity and multiculturalism has multiple languages, histories, and founding moments, its underlying commitment to political work has not been adequately developed as part of a wider project for social reconstruction and progressive change. While issues of racism, class, gender, representation, national identity, subjectivity, and media culture must remain central elements in defining a transformative cultural politics, the issue of radical democracy must be located at the center of its politics. Radical democracy in this instance favors the restructuring of political and economic institutions in ways that permit broad popular control over them. This means creating forms of self-management in all major political, economic, and cultural spheres of society. It also means restructuring social relations so that power flows up from the base of society, not down from the top.[6]

Needless to say, the politics of difference has broadened our understanding of how politics and power work through institutions, language, representations, culture, and across diverse economies of desire, time, and space. But in enabling this vast reconceptualization of power and resistance, it has failed to provide a clear sense of what these sites have in common. By

addressing radical democracy as a political, social, and ethical referent for rethinking how citizens can be educated to deal with a world made up of different, multiple, and fractured public cultures, cultural workers confront the need for constructing a new ethical and political language to map the problems and challenges of citizenship in a newly constituted global public.

At issue is the necessity for cultural workers to develop a collective vision in which traditional binarisms of margin/center, unity/difference, local/national, public/private can be reconstituted through more complex representations of identification, belonging, and community. As Paul Gilroy has recently argued, cultural workers need a discourse of ruptures, shifts, flows, and unsettlement, one that functions less as a politics of transgression than as a part of a concerted effort to construct a broader vision of political commitment and democratic struggle.[7] This suggests a fundamental redefinition of both the meaning of the artist as a public intellectual and how, as educators, we view the sites in which we address our work. As public intellectuals, we must define ourselves not merely as marginal, avant-garde figures, professionals, or academics acting alone, but as critical citizens whose collective knowledge and actions presuppose specific visions of public life, community, and moral accountability. Lynne Sowder, an independent curator, captures the terms of cultural engagement at stake here in stressing that cultural workers "need to find ways not to educate audiences for art but to build structures that share the power inherent in making culture with as many people as possible."[8]

Cultural workers in the age of insurgent differences need an expanded notion of the public, solidarity, and democratic struggle. What is crucial is a conception of the political that is open yet committed, respects specificity without erasing global considerations, and provides new spaces for collaborative work engaged in productive social change. The time has come for cultural workers to develop a political project in which power, history, and human agency can play an active role in constructing the multiple and shifting political relations and cultural

practices necessary for connecting the construction of diverse political subjects to the revitalization of democratic public life. Under these conditions, art would be unsettling without being elitist, and politics would not mean, as Edward Said has pointed out, that the artist or cultural worker had fully arrived, but that one could never go home again.[9]

notes

1 The relationship between art, the public, and democracy can be found in the work of a host of artists and cultural workers too extensive to be cited here. Recent examples of such work can be found in: Suzanne Lacy, ed. *Mapping the Terrain: New Genre Public Art* (Seattle: Bay Press, 1995); Carol Becker, ed. *The Subversive Imagination* (New York: Routledge, 1994); bell hooks, *Art On My Mind* (New York: The New Press, 1995). For a broader view of art, democracy, pedagogy, and politics, see David Trend, *Cultural Pedagogy* (Westport, CT: Bergin and Garvey, 1992). 2 Homi K. Bhabha, interviewed by W.J.T. Mitchell, in "Translator Translated," *Artforum*, March 1995, p. 83. 3 Both of these quotes are taken from Suzanne Lacy, "Introduction: Cultural Pilgrimages and Metaphoric Journeys," in Suzanne Lacy, ed., *Mapping the Terrain: New Genre Public Art*, pp. 20, 43. 4 The distinction between political and politicizing is taken from Peter Euben, "The Debate Over the Canon," *The Civic Arts Review*, Vol. 7, No. 1 (Summer 1994), pp. 4-15. 5 For an exemplary essay on the border intellectual, see Abdul R. JanMohamed, "Worldliness-Without-World, Homelessness-as-Home: Toward a Definition of the Specular Border Intellectual," in Michael Sprinkler, ed., *Edward Said: A Reader* (Cambridge, MA: Basil Blackwell, Ltd., 1992), pp. 97-123. 6 The concept of democracy that I am referring to can be found in the work of Stanley Aronowitz, Chantel Mouffe, Noam Chomsky, and Ernesto Laclau. 7 Paul Gilroy, *The Black Atlantic* (Cambridge, MA: Harvard University Press, 1994). 8 Lynne Sowder quoted in Suzanne Lacy, p. 31. 9 Edward Said, *Representations of the Intellectual* (New York: Pantheon, 1994).

Democracy
and the Idea of the Artist

by Page duBois

In his current bestseller, *The Book of Virtues:*
A Treasury of Great Moral Stories, bed-time tales for
neo-con babies, William Bennett tells the story of Daedalus,
the first artist according to the ancient Greeks.

Daedalus was the maker of a heifer costume for the queen of Crete, who wore it to seduce a bull from the sea and conceived the Minotaur. (This part of the story, involving bestiality, adultery, and the birth of a monster, is, needless to say, elided in Bennett's account.) Daedalus also built the Minotaur's home, the labyrinth of Crete. He constructed wings with wax and feathers, for himself and his son to fly from Crete to Italy, and built a marvelously adorned temple to Apollo there. Bennett retells the story of Daedalus and Icarus's flight, which he glosses ponderously: Icarus, who flew too close to the sun, was a bad boy. Bennett thus concludes:

> *This famous Greek myth reminds us exactly why young people have a responsibility to obey their parents—for the same good reason parents have a responsibility to guide their children: there are many things adults know that young people do not Safe childhoods and successful upbringings require a measure of obedience, as Icarus finds out the hard way.*[1]

Bennett concludes with this praise of obedience, coupled with a subtle threat of disaster for the disobedient. The "great moral story" of Daedalus and Icarus appears in the section of the book called "responsibility," one of those traditional values the former drug czar and minister of education holds most dear—responsibility, like his other categories, "work," "perseverance," and "self-discipline," involves obedience to one's superiors. Bennett is a Platonist, obeying the dictates of that founder of the philosophical tradition, who urged that each man know his place, that the shoemaker stick to his last, that democracy most regrettably and unvirtuously allowed the masses—the great unwashed, the iron men, in his myth of the metals—democracy allowed these unworthy children to make decisions. This means as well that artists should stick to art, challenging only doxa, not true knowledge. Artists should not involve themselves in matters of politics and governance, since the division of labor is the most crucial of divisions.

Is this all the study of antiquity has to offer regarding the problem of the social responsibility of the artist in contemporary culture? I don't think so. One of the things that most interest me

in the current scene is how the image of ancient Greece is again being manipulated, by Bennett and others, to persuade readers and viewers of the immemorial justice of some reactionary political opinion. If ancient Greek philosophers thought something, it must have been true, must still be true, must be an eternal truth. Allan Bloom, in his *Closing of the American Mind*,[2] takes the same sort of line about the ancient Greeks. Those Greeks knew that women should know their place, that education should be only for the elite, as in Plato's circle; Bloom affirms the Greek philosophical tradition, in its abhorrence of democracy and cultivation of patriarchal values, as a stellar model for ourselves.

We must recognize, I think, how deeply anti-democratic American culture really is. Even the political system adopted by our forefathers is not a radical democracy, but a *representative* system, a federal republic. That is to say, a union of states, with representation by white men (in the beginning and almost always since). We have never known a real democracy in this country. The ancient Greek democracy involved assemblies of *all* the citizens of Athens, any one of whom could speak, all of whom could vote on everything, including such questions as whether or not to go to war. In a real democracy, would we all have voted for the bombing of Iraq? I don't think so.

We are currently witnessing a racist, elitist appropriation of ancient culture, which is being used to justify injustice in *our* culture. The myth of ancient philosophy, of the harmony of ancient democracy, serves a certain mythology about the good life, the proper organization of society and politics. Plato's banishment of artists and poets fits into this scheme. It is not artists and poets, in Plato's view, who can represent truth, but only philosophers, those trained in the difficult arts of argument and dialectic. Plato banishes artists and poets because they only *represent*, at a great remove, imitations of imitations of the real, the true, that reside among the gods in a metaphysical realm distant from human existence. It seems to me that Plato's anti-democratic views accompany his anti-art views perfectly. Bennett and Bloom and their ilk are likewise afraid of art, afraid that it represents too much contradiction, diversity, particularity, subjectivity, and isn't

removed enough from everyday life. What they want is the philosopher's perspective, the gaze from very far above the earth, looking down on these petty matters with disdain or indifference.

What can the example of ancient democracy offer us concerning the social responsibility of the artist? I would say that the example of the ancient assembly, in which *every* citizen had a voice, offers some tantalizing possibilities. First of all, such a situation offers the possibility for expression of every point of view. All the contradictions, all the varied and multifarious subject positions we like to consider, every particularity of class, gender, ethnic specificity, as well as every single person's personal history can be adduced for the occasion, and represented as that person desires. Contradictions are thus revealed, exposed, embodied, with no representation by television network executives, or by one's local congressman, or by the President of the United States, or by the National Endowment for the Arts. Such radical democracy might entail this further point, that without the specialization of labor endemic to modern industrial societies, artistic practices might embody a challenge to the seamlessness of contemporary culture. Such practices might call into question the more complacent representations of Postmodernism, presenting versions of heterogeneity as if the two-dimensional representation of diversity ended class, gender, and racial division, as if ad campaigns showing African Americans and so-called Caucasian Americans together in the same image solved the problems of racism and class division in this country.

The democratic view would counter such representations, would show everything. Democracy is an argument for a potentially alarming particularism, for a subjectivity that believes in the micro-representations of individual actors. The argument against such representation is that it fails to acknowledge the possibilities of mass action, of class consciousness, of analysis. I don't agree with that argument. There is no reason why the particular vision of a particular artist or collective cannot include a class identity, a gender identity, an ethnic identity, a class analysis, a global view.

Those analytic categories need not disappear. But their synthesis, their particularity, reside in the work. The complaint is that such a democratic view disregards questions of evaluation, of hierarchy. How do we decide who is best? I think these questions are overrated, that we have focused too long on grading, on relative value, on who is the best. Perhaps the goal should be the dissemination of the capacity to make art to as many people as are interested in making it. The notion that the artist should speak for, speak to, the masses is a Platonic, anti-democratic notion.

In the work of Jacques Rancière—French philosopher, former Althusserian, reader of Plato—we find an alternative to the notion that art is only for artists. In Rancière's view, the most admirable actors in the French revolution were those workers who wanted freedom, time, leisure from labor in order to write poetry, paint paintings, make art. The revolution was fought in part to make such an organization of the day's time possible. I have thought recently that we have become such a culture of spectators we no longer have sex, but instead watch designated others having sex, like the sex-negative characters in the film *Café Flesh*, or the renters of Annie Sprinkle videos. The division of labor has gone this far. And we participate in it, encourage it, when we imagine that the social responsibility of the artist addresses only those who name themselves artists. What about the social responsibility of all of us to do everything? This may sound like a Luddite line; of course we don't all know how to repair VCRs or jet airplanes. I don't mean to argue against skill, complexity, and difficulty. I believe in difficulty, in the value of knowing complicated things. But I still think that in a democracy, the goal should be toward less division of labor and more shared projects, difficulty being the province of all. It should be toward making connections between specializations, rather than fostering the proliferation of hierarchy and increasingly minute categorizations of expertise. And it should be toward the redistribution of wealth.

Plutarch's account of the classical leader Pericles's great building program for the city of Athens names no artist, stressing instead the distribution of the city's wealth to all through his efforts:

It was necessary, now that the city was sufficiently supplied with the necessities for war, to devote the surplus of the treasury to the construction of these monuments, from which, in the future would come everlasting fame, and which while in construction, would supply a ready source of welfare by requiring every sort of workmanship. . . . this so that the population at home would have a claim to derive benefit from and have a share in the public funds. For this undertaking the materials used were stone, bronze, ivory, ebony, and cypress-wood, and those who labored on them were builders, modellers, bronze-workers, stone-cutters, dyers, workers in gold and ivory, painters, embroiderers, and engravers. . . . Thus each art, just as each general has his own army under him, had its own private throng of laborers organized like an army, acting as an instrument and body of public service; so, to sum the whole thing up, briefly, the opportunities for service reached every age and type, and they distributed the wealth accordingly.[3]

The artist employed by the ancient democracy is a laborer, and what surrounds the object—its donor, its effects, its powers, its political meaning as established by the democratic assembly—matters far more than its maker. And what is more, the state, a real democracy, is committed to the redistribution of wealth.

Perhaps we need to think more about the possibility of radical democracy and its effects on art, rather than accepting the facile conservatism of those who want to appropriate ancient history to their own ends. We witness in Greek lyric poetry and in the first signed works of art in Greek antiquity the origins of an ever more evolved individualism. But it would be a mistake to see the naming of individual artists in the ancient world as equivalent to our own art practices, with their celebration of individual genius and of the commodified art object. In the world of classical antiquity, the objects themselves had a residual authority, divine or magical, that sometimes superseded any recognition of their makers. Ancient works of art were remembered as gifts of their donors rather than as productions of the genius of makers, or as occasions for the redistribution of wealth to all citizens. It is only

our hunger for names, our emphasis on individualism, that lead to an art history based on the names of artists, or even of art as a fetishized category, as a series of commodities produced by post-Romantic artists. We need a historical sense of the production of the idea of art, of the idea of the artist, if we are to think ourselves into the future, perhaps even into an unfamiliar, unknown, utopian landscape of collective, anonymous, political works.

These are meant as polemical suggestions, ones that I know will not necessarily meet with favor in an assembly of artists. I may seem to be making an argument for amateurism and for macramé clinics on every block in America. But I still think that resistance to the elitism embodied by William Bennett is required. He and his ilk want an art that pretends to transcend class and history, an art that obscures and erases the divisions in our culture, that actually represents only one class, one gender, one ethnicity, but claims to represent all mankind. If we are to use history to think about the present and the future, perhaps the ancient democracy of the Greeks can help us to think about alternatives to such a vision. And it might be one that takes seriously those divisions, microscopic as they may become, that takes seriously the aspirations of every citizen, or perhaps better every *resident* in the world, to make art. It is not as if the machinery and apparatus of the production of artists is not itself class-bound, riddled with privilege and prejudice. Maybe we should consider the possibility that real democracy means every woman, every man an artist, that real democracy means a radical redistribution of the wealth in this country.

notes

1 William Bennett, *The Book of Virtues: A Treasury of Great Moral Stories* (New York: Simon & Schuster, 1993), p. 211. 2 Allan Bloom, *The Closing of the American Mind* (New York: Simon & Schuster, 1987). 3 Plutarch, *Life of Pericles*, trans. John Dryden (New York: Random House, n.d.), pp. 191-192.

The Enchantment of Art

Homi K. Bhabha

Not all migrants are powerless, *the still standing edifices whisper. They impose their needs on the new earth, bringing their own coherence to the new-found land, imagining it afresh. But look out, the city warns. Incoherence, too, must have its day.* ~**Salman Rushdie,** ***The Satanic Verses***[1]

24

The enchantment of art lies in looking in a glass darkly—a wall, stone, a screen, paper, canvas, steel—that turns suddenly into the almost unbearable lightness of being. My mixed-media metaphor moves restlessly between a clichéd phrase from St. Augustine to Milan Kundera's title, from the dark night of the soul and its shadows to the obscure, dazzling object of desire, from philosophy to films, from looks to books. In this interdisciplinary *errancy*, I seek a name for the visual arts between the two registers of light caught in my opening metaphor: lightness or "lighting" as naturalized in the production of the visual image *as a form of likeness*, a mimetic light; and a "lightness of being" that is apparent in contemporary art practice—a "lightness" that is neither levity nor devoid of agonism or suffering; a lightness that comes with ironic reversal, an alleviation and unburdening, a demotic defiance, a vernacular violence, a subversion of the sententious: a lightness, or a quality of *visible light*, that has its own specific gravity, and represents a struggle for survival.

It is precisely such a subversive light that Barbara Kruger cast on the problem of personhood—on what it means to be a subject in our late-modern age—when, looking darkly through thick panes of mottled, beveled glass, she suggested in one of her finest, earlier works that "YOU THRIVE ON MISTAKEN IDENTITY."[2] Much radical, innovative art practice today suggests that the subject is constituted as a discursive or ideological "effect": *The gaze is outside. I am looked at.* This is often misunderstood as producing a politically passive identity. Such a misunderstanding implies that "intentionality" requires a totalized, unitary consciousness. In fact, the importance—and disturbance—of placing the "gaze" outside the intimation of individual identity is that it emphasizes that the position of the human subject is neither Inside (the psyche) nor Outside (in the social). Identity is an *intersubjective*, performative act that refuses the division of public/private, psyche/social. It is not "self" *given to* consciousness, but a *coming to* consciousness of the self through

the realm of symbolic otherness—language, the social system, the unconscious.

When the psychoanalyst Jacques Lacan fragments and hyphenates the word "Photo-graph" in his discussion of how social subjects are formed, he provides us with a concise, if cryptic cipher of the disjunctive conditions that inform the structure of social identification. Identity becomes the problem of negotiating and articulating *photo*—the lightening likeness of the image, the shutter-speed of recognition—with *graph*—the deciphering of the inscriptive, the diachrony of narrative and historicity, the alterity of the sign. The gaze and the grapheme come together—are articulated—in an ambivalence and splitting of the subject that enables identity to be strategic and effective because of its structure as a contingent, "double" consciousness.

I learned the political effectivness of such a double consciousness from an unassuming photographer called Mr. Styles in a cockroach-ridden studio in the New Brighton township of Port Elizabeth, South Africa. There is something quite campy about his name—Styles—something appropriate to the themes of mimicry and camouflage, the devices of displacement he must use in the milieu of his work—camp and South African apartheid labor laws. In Athol Fugard's book *Sizwe Bansi Is Dead*, Styles, the photographer, recycles work-permits. By replacing the identifying photograph on a pass, Styles fits out a township worker with a new identity. But, as one of his clients protests, that means living life as a ghost. Mr. Styles shoots back: "When the white man looked at you at the Labour Bureau what did he see? A man with dignity or a bloody passbook with an N.I. number? Isn't that a ghost? . . . All I'm saying is to be a real ghost, if that is what they want . . . *Spook them into hell, man!*"[3]

One way of concretely envisioning such an art practice—one that "spooks them into hell!"—is demonstrated in the work of

the African-American artist Adrian Piper. Her series "Pretend" stages the fetishistic dynamic of the sexual gaze across the history of the Civil Rights movement. Her work presents portraits of black men—Martin Luther King, Jr. among them—each of them bearing a piece of the text: "Pretend not to know what you know." The unmarked icon at the end of the series shows three apes in the familiar see-no-evil/hear-no-evil/speak-no-evil triptych. Piper substitutes the mother figure of the Freudian scenario of fetishism with the black father figure of the Civil Rights movement. The signifier of sexuality, with its splitting of identity, haunts the male icon of racial victimage that seeks to constitute itself in a political/prophetic tradition of patriarchal activism. The spectator's identification with the visual image cuts both ways, Janus-faced, across lines of sexual and racial difference. The viewer cannot help but occupy an ambivalent social position: There is the identification with the visible African-American history of racial victimage and the struggle against it; there is, at the same time, an interrogation of the patriarchal sexual culture within black civil-rights "race" politics, the historic erasure of the agency of women and gay and lesbian activists. Social splittings of form and content are at the core of Piper's work, a critic has written.[4] Piper instructs us in "Pretend," I think, that "what-we-see-is-not-what-we-need-to-get-or-desire" in both our psychic and political lives.

Why do these "living ghosts" (in Mr. Styles's sense), these culturally hybrid identities that are constituted in the cause of minority empowerment or social equity, why do they spook the hell out of critics like Hilton Kramer? Precisely because, I suggest, he and his ilk are unable to tolerate the passing of an aesthetic and social value system based on grand oppositions—high art and populist culture, the "artist" and the people. What Kramer cannot represent—and radically *mis*represents in his celebrated essay "Art and Its Institutions"[5]—is a form of cultural value that does not depend on binary divisions. In objecting to the importation of the standards of the social sciences into the realm of

aesthetic consideration, Kramer wants to disavow all those mediatory, articulatory elements—class, community, equity, access, race, sexuality—that define cultural production as an interdisciplinary structure continually involved in border crossings and intertextual negotiations.

The sense that value may lie in the articulation of "unlikely" social institutions—the museum and the community center, for example—becomes for Kramer the occasion for a call to arms: "the culture war is also a moral and social crisis of vast dimensions." [6] As everyday culture becomes more marked by what I have called a double, or hybrid consciousness, Kramer resorts to the discourse of war and paranoia to redraw the binary boundaries between the nationalist interest and its core culture, and those disenfranchised, "affirmative-action" cohorts who occupy the position of the minorities. His sense of an imagined community of cultural affiliation cannot now be conceived without reviving memories of Vietnam and yearning for the metaphor of the Cold War, which kept the home fires burning clean.

Kramer may win some media battles, but he is in danger of losing the culture war. There is an overwhelming apprehension that the "new internationalism" is being inaugurated at a time of a peculiar historical *intermediacy*: the 1992-93 Sydney Biennale was launched under the sign of "the boundary rider" who, the curator writes, "accepts that strangely constant, fluid state which exists between fixed concepts." [7] The controversial 1993 Whitney Biennial chose to explore the borderline communities that inhabit the world of contemporary American art while emphasizing the failure of a new communitarian consensus. The 1993-94 National Photography Conference in Bristol, England was organized around the instructive ambivalence of "disrupted borders": the title of a show that drew attention to those artistic practices and cultural communities that have been obscured by the "international style" of Modernism. [8] How do we conceptualize, and visualize, the *intermediacy*, the in-between borderline nature

of our current historical phase—a phase that the influential British leftist journal *New Left Review* has recently described as a period that lies precariously somewhere between barbarism and the Enlightenment?

Carol Becker's introduction to *The Subversive Imagination* gives us a vital sense of the complex disagreements about the nature of democracy that underlie the culture wars. Her exemplary argument, that the most controversial works of art "challenge the most originary notions of modern society, and risk the consequences,"[9] cites a range of works: prominent among them, collages of the Virgin of Guadalupe overlaid with the face of Marilyn Monroe, Martin Scorsese's *The Last Temptation of Christ*, and the *fatwah* pronounced against Salman Rushdie's *Satanic Verses*. What has proved controversial about each of these works is, indeed, what characterizes the intermediate, transitional, and yet transformative social ethic of our times: living on the edge of the Enlightenment and being forced to re-examine the shibboleths of secularism.

The trouble with concepts like individualism, liberalism, or secularism is that we think we understand them too well. These are ideas, and ideals, that are increasingly complicit with a self-reflective claim to a culture of modernity, whether it is held by the elites of the East and West, or the North and South. We may define them in different ways, assume different political or moral positions in relation to them, but they seem "natural" to us: it is as if they are instinctive to our sense of what civil society or a civic consciousness must be. Despite their limitations, these ideas have a certain "universal" historical resonance: a universality that comes from the origins of these concepts in the value system of the European Enlightenment. It is such universality, argues Eric Hobsbawm, in my view the greatest socialist historian of our own era, that stands as a bulwark between civility and "an accelerated descent into darkness."[10]

I would suggest that these concepts of a modern political and social lexicon have a more complex history. If they are immediately, and accurately, recognizable as belonging to the European Enlightenment, we must also consider them in relation to the colonial and imperial enterprise *that was an integral part of that same Enlightenment.* For example, if liberalism in the West was rendered profoundly ambivalent in its avowedly egalitarian project, when confronted with class and gender difference, then, in the colonial world, the famous virtue of liberal "tolerance" could not easily extend to the demand for freedom and independence when articulated by native subjects of racial and cultural difference. Instead of independence they were offered the "civilizing mission"; instead of power, they were proffered paternalism.

Thus, it is this complex, self-contradictory history of "universal" concepts like Liberalism, *transformed through colonial and post-colonial contexts*, that is particularly important to our current social and cultural debates in a multicultural, multi-ethnic society. In order to understand the cultural conditions, and the rights, of migrant and minority populations, we have to turn our minds to the colonial past, not because it reveals to us the countries of our "origins," but because the values of many so-called "Western" ideals of government and community are *themselves* derived from the colonial and post-colonial experience.

The problems of secularism we confront today, particularly in relation to censorship, blasphemy, and minority rights, may have a long history, but they have had a very specific *post-colonial* resonance since the *fatwah* against Rushdie. They are problems that have arisen through the cultural and political impact of migrant and minority communities on the British state and nation. We must be very cautious and circumspect in our use of the term "secularism" after its abuse by many spokespersons of the Eurocentric liberal "arts" establishment, who have used it to characterize the "backwardness" of migrant communi-

ties in the post-*Satanic Verses* cataclysm. Great care must be taken to separate secularism from the unquestioned adherence to a kind of ethnocentric and Eurocentric belief in the self-proclaimed values of modernization.

The traditional or classic claim to secularism is grounded in an unreconstructed liberalism of the kind I described above—a liberalism devoid of the crucial interpolation of its colonial history. Such secularism often "imagines" a world of equal individuals who determine their lives, and the lives of others, rationally and commonsensically. This is a "secularism" of the privileged, a perspective far removed from the cultural and national context in which various minority groups like Women Against Fundamentalism (WAF) are demanding an adherence to secularism. The secularism that is demanded by WAF, for instance, is based on an awareness of the gendered critique of rationalism (emphatically *not* rationality), and the passion that is provoked by racism and sexism in the control of minorities: this control may be exerted by state institutions against minority groups, or by patriarchal and class structures within minority communities themselves. What we need is a "subaltern" secularism that emerges from the limitations of "liberal" secularism and keeps faith with those communities and individuals who have been denied, and excluded from the egalitarian and tolerant values of liberal individualism. I am not using the word subaltern in its militaristic application. I am using it in the spirit of the Italian Marxist Antonio Gramsci, who used the term to define oppressed, minority groups whose presence was crucial to the self-definition of the majority group: subaltern social groups were also in a position to subvert the authority of those who had hegemonic power: YOU THRIVE ON MISTAKEN IDENTITY.

Now my attempt to "translate" secularism for the specific *experiential* purposes of marginalized or minority communities who are struggling against various hegemonic oppressions of race, class, gender, generation—what I have called

"subaltern secularism"—is brought to life brilliantly in a few pages in Gita Sahgal's essay "Secular Spaces: The Experience of Asian Women Organizing":

> *Many women's centres are secular in their conduct rather than specifically in their aims or their constitution. Welcoming women from different religious backgrounds, they create the space to practise religion as well as challenge it. This is peculiarly difficult for multiculturalist policy-makers to grasp. Having abandoned the egalitarian ideal for a policy of recognizing cultural differences, they tend to have to codify, implement and reinforce these differences (as British colonialism did in relation to family law). For instance, a well-meaning social worker, enquiring into cooking arrangements in the refuge, was told there were two kitchens. "Ah, yes," she said knowledgeably, "one vegetarian and one non-vegetarian." "No," we said, "one upstairs and one downstairs." . . . The difficulty for secularists, particularly those who have embraced a pluralist ideology rather than being complete atheists, is that they cannot offer a complete identity to people in search of their roots. With the breaking down of the traditional distinctions between public and private spheres, the idea itself is in the process of redefinition. Secularists can, however, raise awkward questions: for instance, about how the experience of domestic violence and the challenge to family values have radicalized many women. But their involvement in Southall Black Sisters or the Brent Asian Women's Refuge has not made women into clones of the feminists who run these projects. The engagement with the depth and complexity of the response to religion is just beginning. It is only in a secular space that women can conduct the conversation between atheist and devotee, belief and unbelief, sacred and profane, the grim and the bawdy.[11]*

What Gita Sahgal articulates through the "space" of the refuge, which becomes a metaphor for the idea of an "emergent" secular community, is an ethical freedom of *choice*. Fundamentalism limits choice to a pre-given authority or protocol of precedence and tradition. Secularism of the liberal variety, which I have criticized, suggests that "free choice" is inherent in the individual—this, as I have argued, is based on an unquestioned "egalitarianism" and a utopian notion of individualism that bears no relation to the history of the marginalized, the minoritized, the oppressed.

But the secularism—the subaltern secularism—that I see defined in Sahgal's exemplary exposition of the politics of the everyday, and the politics of the experiential, is not a pre-supposed or prescribed value. The process of choice and the ethics of coexistence come from the social space which has to be communally shared with others, and from which solidarity is not simply based on similarity but on the recognition of difference. Such a secularism does not assume that the value of freedom lies within the "goodness" of the individual; freedom is much more the testing of boundaries and limits as part of a *communal, collective* process, so that "choice" is less an individualistic internal desire than it is a public demand and *duty*. Secularism at its best, I believe, enshrines this public, ethical duty of "choice" precisely because it often comes from the most private experiences of suffering, doubt, and anxiety. We need to "secularize" the public sphere so that, paradoxically, we may be free to follow our strange gods or pursue our much-maligned monsters, as part of a collective and collaborative ethics of choice.

notes

1 Salman Rushdie, *The Satanic Verses* (New York: Viking, 1989), p. 458.
2 Barbara Kruger, *Untitled (You Thrive on Mistaken Identity)*, 1981. 3 Athol Fugard, *Sizwe Bansi Is Dead,The Township Plays* (Capetown, South Africa and Oxford, England: Oxford UP, 1993), p. 185. (Emphasis added.) 4 Arlene

Raven, "Civil Disobedience," *The Village Voice*, September 25, 1990, pp. 55, 94. **5** Hilton Kramer, "Art and Its Institutions: Notes on the Culture War," *The New Criterion*, September 1993, pp. 4-7. **6** Ibid, p. 7. **7** Anthony Bond, "Notes on the Catalogue and Exhibition," *The Boundary Rider: 9th Biennale of Sydney*, exhibition catalogue (Sydney, N.S.W.: Biennale of Sydney, Ltd., 1992), p. 16. **8** See *Disrupted Borders: An Intervention in Definitions of Boundaries*, edited by Sunil Gupta (London: Rivers Oram Press, 1993). **9** Carol Becker, "Introduction: Presenting the Problem," *The Subversive Imagination: Artists, Society, and Responsibility*, edited by Carol Becker (New York: Routledge, 1994), p. xiv. **10** Eric Hobsbaum, "Barbarism: A User's Guide," *New Left Review*, July/August 1994, p. 45. **11** Gita Sahgal, "Secular Spaces: The Experience of Asian Women Organizing," *Refusing Holy Orders: Women and Fundamentalism in Britain*, edited by Gita Sahgal and Nira Yuval-Davis (London: Virago Press, Ltd., 1992), pp. 192, 197.

Proposition One

by Kathy Acker

I want to begin this by talking about something that just happened to me. First, let me set the stage.

Idaho On November 2 of this year,[*] Idaho voters will cast their ballots for or against a piece of legislation labeled Proposition One. If enacted, Proposition One would establish the following policies:

> *Providing that no state agency, department or political sub-*
> *division shall grant minority status to persons who engage*
> *in homosexual behavior; providing that same-sex mar-*
> *riages and domestic partnerships shall not be legally recog-*
> *nized; providing that elementary and secondary school*
> *educators shall not discuss homosexuality as acceptable*
> *behavior; providing that no state funds shall be expended*
> *in a manner that has the effect of accepting or approving*
> *homosexuality; limiting to adults access to library materials*
> *which address homosexuality; providing that private sexual*
> *practices may be considered non-job factors in public*
> *employment; and providing a severability clause.*[1]

The struggle, the fury surrounding Proposition One in Idaho rises up from a larger and deeper issue: the differences between those in the religious Right and those who are not or who are no longer fundamentalist. It is possible that the fight over Proposition One and similar laws heralds the appearance of a new round of religious wars in this country.

It was into this environment that I unwittingly, ignorantly, walked three weeks ago. The English department of the University of Idaho (UI) had hired me to teach a two-week intensive course and, during that time, to present a reading of my fictional work.

This reading was held three days after my teaching began.

Unbeknownst to me, a play had begun prior to my reading at UI. Before my arrival, some of the literature professors and the dean had discussed whether police should be present at my performance. However, when I asked the professor who was "in charge of me" if there would be any problem if I publicly read material that was explicitly sexual, he replied, "Of course not. The more, the merrier." So to speak.

[*] This essay was originally delivered as a speech on October 14, 1994, at "The Artist in Society" conference in Chicago

I shall read you some brief excerpts from the review of my performance written by one of the school newspaper's editors:

An interesting fact is that we are in the midst of "Banned Books Week." Not only should this author's books be banned, but the author herself as well . . . I was not forewarned that this reading would be highly offensive with many references to lesbian sexual encounters (something I know nothing about and would have preferred to keep that way).[2]

According to the review, my major sins were that I used the words "c—" and "f—" (that's how they were printed in all the newspapers), that I depicted lesbian love, and that my narrative was difficult to follow. Apparently, a difficult read, or listen, is not a proper commodity. I say the word "sins" carefully—after my reading, a student accused me of being possessed by demons.

Two days later, the editor-in-chief of the same school newspaper interviewed me, and letters of protest deluged the paper. Then letters protesting the letters of protest began to appear. One result of all this was that the major newspaper in that part of the world, *The Lewiston Tribune*, picked up the story. That paper spent the week interviewing me; the day I left town (probably fortunately for me), huge colored photos of me accompanied an equally colored interview—an interview with a pornographer (that's me)—all over the front page of the entertainment section. Dolly Parton occupied the back page.

I shall return, not to this story, which I've somewhat lightly told, but to its matter, the matter of the story, by a circuitous route. I want to discuss the poet's relation to his or her society; I want to discuss precisely, though briefly, one type of poet or fiction writer-to-society relation, that of marginalization; I want to discuss one place where this marginalization began. Then I will turn to the present, to our present. I will look at the poet or fiction writer now, at his or her current relation to society, at this marginalization today. Finally, I want to place literary marginalization today in the context of, for instance, Proposition One in Idaho.

I shall begin by speaking of the literary lineage to which my own writing is closest; I shall trace the beginnings of marginalization there.

Baudelaire Born in 1821, Charles Baudelaire, fearing the economic and social power of a burgeoning bourgeois society, directly and indirectly posited the poet as he (in those days, they didn't say "she"), as he who cannot and must not bear this society. As he who does not seek to please and entertain a rich patron, as heretofore, but rather as he who chooses in his writing and in his life, in every way possible, to be unlike, to defy.

In his prose poem "Anywhere out of the world," Baudelaire is talking with his own soul. Baudelaire begins this dialogue; he states that "Life is a hospital." But he wants to please his soul, so he searches for places of safety, geographies, where his soul may enjoy residing. After all, there must be something, somewhere, in this world that can give his soul pleasure. The soul is not interested; the soul does not want any of this. I will go anywhere, finally replies the soul, ". . . anywhere, as long as it be out of this world!"[3]

Baudelaire in his poetry entered an artistic society in which literature was written with consummate irony, with elegance, in order to please, even to educate, those whose taste was impeccable: the upper-middle classes. Again, Baudelaire:

> *I . . . saw the city as from a tower,*
> *Hospital, brothel, prison, and such hells.*[4]

This is the city he desires, not the gathering place of the rich, the educated, the Parnassians, the literati, for he continues:

> *I love thee, infamous city! Harlots and*
> *Hunted have pleasures of their own to give,*
> *The vulgar herd can never understand.*[5]

Rimbaud Born in 1854, Arthur Rimbaud deepened and broadened Baudelaire's distaste for society. Cast out even by the rebel poets whom he had sought, this kid turned directly against

every possible social and political position, against the liberals of his time as well as the tyrants, against both "masters and workers." Here is Rimbaud the slacker in his "Bad Blood":

> *I have a horror of all trades. Masters and*
> *workers—base peasants all.*[6]

Not content with class distinctions, Rimbaud attacks literature:

> *The hand that guides the pen is worth the hand that*
> *guides the plough. —What an age of hands!*
> *I shall never have my hand.*[7]

Here's a description of literary praxis of literary structure! I shall never have any hand!

> *But who gave me so perfidious a tongue* [the kid
> continues], *that it has guided and guarded my*
> *indolence till now? Without ever making use of my body*
> *for anything, and lazier than the toad, I have lived*
> *everywhere. Not a family of Europe that I do not know.*
> *—I mean families like my own that owe everything to*
> *the Declaration of the Rights of Man.*
> *—I have known all the sons of respectable families.*[8]

Remember, Rimbaud's mother was a religious fanatic.

Both Baudelaire and Rimbaud posited themselves as writers against a society of power. They saw themselves, writers, as dandies, friends of whores, slackers—as anything but powerful.

Artaud or Our Toad The most alienated of all Western poets, Antonin Artaud. Rhymes with Rimbaud.

Artaud has shown us that to be a poet is to be more than marginal, it is to be alienated from our society to the point of madness.

Artaud has shown us that the political structure of this society is inextricably tied to the structure of that which first socializes, the structure of the family. "This child/kid," Artaud wrote, "He isn't there / he's only an angle." (Remember the Oedipal

triangle or The Holy Trinity.) "he's only an angle . . . that's about to happen / as yet there's no angle."[9]

Listen to Artaud's madness, to the ways in which, here, he connects his personal suffering to the political world:

> *this world of mother-father is justly that / which must go away, / for this is the world of split-in-two / in a state of constant disunion / also willing constant unification*[10]

In this passage, Artaud is discussing how the political structure shapes and defines identity.

This political structure, this world of mother-father, Artaud concludes,

> *is turning the whole system of the world malignantly sustained by the most somber organization.*[11]

Now discussing a fellow mad artist, Artaud comments,

> *One can speak of the good mental health of van Gogh who, in his whole life, cooked only one of his hands and did nothing else except once to cut off his left ear, in a world in which every day one eats vagina cooked in green sauce* [Artaud the feminist?] *or penis of newborn child whipped and beaten to a pulp.*[12]

What, we must ask, is this *good health* that van Gogh maintained? What is the good health of artists who live at the margin, the margins of society, the margin between sanity and madness?

Gilles Deleuze and Félix Guattari, in their groundbreaking text *Anti-Oedipus*, lead us to recall the writings of Antonin Artaud, recall the life of Artaud, citing R.D. Laing: "Madness need not be all breakdown. It may also be breakthrough."[13] Like Artaud, they analyze madness by situating it in the larger, political world:

> *What is at stake is not merely art or literature. For either the artistic machine, the analytic machine, and the revolutionary machine will remain in extrinsic relationships that make them function in the deadening framework of*

*the system of social and psychic repression, or they will
become parts and cogs of one another in the flow that
feeds one and the same desiring machine*"[14]

In this passage, Deleuze and Guattari are discussing schizo-
phrenia, the schizophrenia, for instance, that must result when
the art body is separated from the political body. Schizophrenia
is that which stops the flow. How can this unhealthy, repressive-
because-repressed, stoppage be overcome? "How does one get
through this wall?"[15]

Baudelaire, Rimbaud, Artaud, and their ilk viewed their
writing—every aspect, content and structure, because their very
lives, their life-decisions—as politically defined. Where are we,
we who are born from these poets, at present?

The Present At this moment in the United States, there are
six major literary publishing houses, two or three mid-range
ones, and a large number of small presses. Since the chain
bookstores, which are increasingly dominating the market,
buy mainly from the six large publishing houses, those publish-
ers monopolize distribution. But not only distribution. The
major publishing houses have both immense publicity budgets
and incredible access to major media.

Generally, the majors, whose interest is increasingly in sales,
publish only those fictional and poetic texts written according
to certain rules, regulations governing structure, style, and
language, texts written in order to sell.

A close friend of mine, a poet, said to me that when she began
establishing herself as a writer, she did not want to make and
compose according to the rules of literary commodity, that she
wished to find out how she wanted to write. She desired to find
her own structures, thus contents. She chose, for there seemed to
her to be no other choice, to work and to live outside the literary
commodity system; she chose to be an "experimental" writer.

"Only in this way," says Carla, "can I write as I please, as I must."

Carla understood and understands that, in this country,
"experimental" equals "marginal"; that no one—meaning

neither the major publishing houses nor the chain bookstores—wants "experimental" work—even though those publishing conglomerates have recently been experiencing serious financial problems.

I am not attempting to analyze literary capitalism; I only wish to make the following two points:

First: The equation "experimental writing equals marginal writing" need not be a true equation. Allen Ginsberg's *Howl*, as "experimental" a text as any when it first appeared, was not and certainly is not marginal to specific formations in this society. It is the major publishing houses, the chain bookstores, and the connected media, in search of larger profits, who are maintaining, who are reifying the split between commercial and non-commercial, or "experimental," literature. They are telling us, teaching us to read only that fiction and poetry whose structures, the structures of commodity, support the status quo. Nonetheless, the kids—my students, perhaps yours—when they do read on their own, go for books by William Burroughs, by theorists such as Michel Foucault and Teresa de Laurentis; the kids, my students, *want* to read texts which are difficult, disjunctive, not "a good read."

Second: I'm going to return to my friend Carla, the poet. She explains that she prefers to remain in the non-commercial (the bohemian, the experimental) world, for there she is safe. Safe to be able to write as she sees fit. Safe because her audience, though small, strongly supports her work. She does not encounter the religious Right of Idaho.

In other words, it is not only the major publishing houses who support the "experimental-equals-marginal" equation. It is the "experimental" writers themselves, for they have and are internalizing the literary conventions and restrictions that support the status quo. By internalizing these definitions and expectations, by accepting literary and personal marginalization, the non-commercial writer denies the political realities surrounding and underlying his or her literary choices.

Back to Idaho. My non-private Idaho. To be marginal is to be

on a margin. Fortunately or unfortunately, the religious Right is putting the margin—that desperate balancing act—out of business. There are no longer any safe places in our world. Innocence will soon be dead: the writer who chooses to write in ways that do not support the status quo can no longer rest in elitism, but, as was the case with Baudelaire, Rimbaud, and Artaud, must make clear the reasons for writing the way she or he does, must make those reasons, which are also and always political positions, present.

Finally, as always, Artaud, Artaud talking about another mad author, the Comte de Lautréamont:

> *Because people were afraid that their poetry would escape from their books and overthrow reality . . .*[16]

notes

1 Text of "Proposition One: An Act Establishing State Policies Regarding Homosexuality," which appeared on Idaho ballots in November, 1994. Proposition One was defeated. 2 Amy Ridenour, "Acker's Fiction Reading Offensive, Pornographic," *The Argonaut* (University of Idaho), September 30, 1994, p. 8. 3 Charles Baudelaire, "Anywhere out of the world," trans. by Arthur Symons in Joseph M. Bernstein, ed., *Baudelaire, Rimbaud, Verlaine* (New York: The Citadel Press, 1947), pp. 163-164. 4 Baudelaire, "Epilogue," *Baudelaire, Rimbaud, Verlaine,* p. 169. 5 Ibid. 6 Arthur Rimbaud, "Bad Blood," *Baudelaire, Rimbaud, Verlaine,* p. 174. 7 Ibid. 8 Ibid. 9 Antonin Artaud, quoted in Gilles Deleuze and Félix Guattari, *Anti-Oedipus: Capitalism and Schizophrenia* (Minneapolis: University of Minnesota Press, 1983), p. 122. My translation from the French. 10 Ibid. 11 Ibid. 12 Artaud, "Van Gogh, The Man Suicided By Society (1947)," in Susan Sontag, ed., *Antonin Artaud, Selected Writings* (New York: Farrar, Straus, and Giroux, 1976), p. 483. 13 R.D. Laing, cited in Deleuze and Guattari, *Anti-Oedipus,* p. 131. 14 Ibid., p. 137. 15 Vincent van Gogh, cited in Deleuze and Guattari, p. 136. 16 Artaud, "Letter About Lautréamont," *Antonin Artaud, Selected Writings,* p. 471.

Gangsta Rap:
Representation, Transgression,
and the Race Artist

by Michael Eric Dyson

As a 35-year-old father *of a 16-year-old son, and as a professor, public intellectual, cultural critic, and ordained Baptist minister who grew up in Detroit's treacherous inner city, I am disturbed by many elements of gangsta rap.*

But I am equally anguished by the way many critics have scapegoated its artists, blaming them for problems that bewitched our culture long before they came on the scene. How can we avoid this pitfall of unfairly attacking artists and black youth?

First, we should understand what forces drove the emergence of rap. Second, we should place the debate about gangsta rap within the context of a much older debate about "negative" and "positive" black images. And finally, we should acknowledge that gangsta rap crudely exposes harmful beliefs and practices that are often maintained with deceptive civility in much of mainstream society, including many black communities.

If the 15-year evolution of hip-hop teaches us anything, it's that history is made in unexpected ways by unexpected people with unexpected results. Rap is now firmly established, safe from the perils of quick extinction that were predicted at its humble start. But its birth in the bitter belly of the '70s proved to be a Rosetta stone of black popular culture. Afros, "blunts," funk music, and carnal eruptions define a "back-in-the-day" hip-hop aesthetic. In reality, the fiscally severe '70s busted the economic boom of the '60s. The fallout was felt in restructured automobile industries and collapsed steel mills. It was extended in domestic employment opportunities exported to foreign markets. Closer to home, there was the depletion of social services which were intended to reverse the material ruin of black life. More recently, most public spaces for black recreation have been either gutted by Reaganomics or violently transformed by lethal drug economies.

Hip-hop was born in these bleak conditions. Hip-hoppers joined pleasure and rage while turning the details of their difficult lives into craft and capital. This is the world hip-hop would come to "represent": privileged persons speaking for less visible or vocal peers. At their best, rappers shape the torturous twists of urban fate into lyrical elegies.

They represent lives swallowed by too little love or opportunity. They represent themselves and their peers with aggrandizing anthems that boast of their ingenuity and luck in surviving. The art of "representin'" that is much ballyhooed in hip-hop is the witness of those left to tell the afflicted's story.

As rap expands its vision and influence, its unfavorable origins and its relentless quest to represent black youth are both a consolation and a challenge to hip-hoppers. They remind rappers that history is not merely the stuff of imperial dreams from above. It isn't just the sanitizing myths of those with political power. Representing history is within reach of those who seize the opportunity to speak for themselves, to represent their own interests at all costs. Even rap's largest controversies are about representation. Hip-hop's attitudes toward women and gays continually jolt us with the unvarnished malevolence they reveal. The sharp responses to rap's misogyny and homophobia signify its central role in battles over the cultural representation of other beleaguered groups. This is particularly true of gangsta rap.

While gangsta rap takes the heat for a range of social maladies from urban violence to sexual misconduct, the roots of our racial misery remain buried beneath moralizing discourse that is confused and sometimes dishonest. There's no doubt that gangsta rap is often sexist and that it reflects a vicious misogyny that has seized our nation with frightening intensity. It is doubly wounding for black women, who are already beset by attacks from outside their communities, to feel the stab of musical daggers to their dignity from within. How painful it is for black women, many of whom have fought valiantly in support of black pride, to hear the dissonant chord of disdain carried in the angry and frequent epithet, "bitch."

The link between the vulgar rhetorical traditions expressed in gangsta rap and the economic exploitation that

dominates the marketplace is real. The circulation of brutal images of black men as sexual outlaws and black females as "'hos" in many gangsta rap narratives mirrors ancient stereotypes regarding black sexual identity. Male and female bodies are turned into commodities. Black sexual desire is stripped of its redemptive uses in relationships of great affection or love.

Gangsta rappers, however, don't merely respond to the values and visions of the marketplace; they help shape them as well. The ethic of consumption that pervades our culture certainly supports the rapacious materialism shot through the narratives of gangsta rap. Such an ethic, however, does not exhaust the literal or metaphoric purposes of material wealth in gangsta culture. The imagined and real uses of money to help one's friends, family, and neighborhood occupy a prominent spot in gangsta rap lyrics and lifestyles.

Also troubling is the glamorization of violence and the romanticization of the gun culture that pervades gangsta rap. The recent legal troubles of Tupac Shakur, Dr. Dre, Snoop Doggy Dogg, and other gangsta rappers chastens any defense of the genre based on simplistic claims that these artists are merely performing roles that are divorced from real life. Too often for gangsta rappers, life does indeed both imitate and inform art.

But gangsta rappers aren't *simply* caving in to the pressure of racial stereotyping and its economic rewards in a music industry hungry to exploit their artistic imaginations. On this score, gangsta rappers are easily manipulated pawns in a game of material dominance, where either their consciences are sold to the highest bidder, or they are viewed as the black face of a white desire to distort the beauty of black life. It has even been suggested that white record executives discourage the production of "positive rap" and reinforce the desire for lewd expressions packaged as cultural and racial authenticity.

But such views are flawed. The street between black

artists and record companies runs both ways. Even though black artists are often "ripe for the picking"—and thus susceptible to exploitation by both white- and black-owned record labels—many of them are quite sophisticated about the politics of cultural representation. Gangsta rappers themselves helped to create the genre's artistic rules. Further, they have figured out how to financially exploit sincere and sensational interest in "ghetto life." Gangsta rap is no less legitimate because many "gangstas" turn out to be middle-class blacks faking homeboy roots. This simply focuses attention on the genre's essential constructedness, its literal artifice. Much of gangsta rap makes voyeuristic whites and naïve blacks think they're getting a slice of authentic ghetto life, when in reality they're being served colorful exaggerations. That doesn't mean, however, that the best of gangsta rappers don't provide compelling portraits of real social and economic suffering.

Critics of gangsta rap often ignore how hip-hop has been developed without assistance from the majority of black communities. Even "positive" or "nation-conscious" rap was initially spurned by those now calling for its revival in the face of gangsta rap's ascendance. Long before white record executives sought to exploit transgressive sexual behavior among blacks, many of us failed to lend support to politically motivated rap. For instance, when the political rap group Public Enemy was at its artistic and popular height, most of the critics of gangsta rap didn't insist on the group's prominence in black cultural politics. Instead, Public Enemy and other conscientious rappers were often viewed as controversial figures whose inflammatory racial rhetoric was cause for caution or alarm. In this light, the hue and cry directed against gangsta rap by the new defenders of "legitimate" hip-hop rings false.

Also, many critics of gangsta rap seek to curtail its artistic freedom to transgress boundaries defined by racial or sexual taboo. That's because the burden of representation—

in a far different manner than the one I've described above—falls heavily on what may be termed the "race artist." The race artist stands in for black communities. The race artist represents millions of blacks by substituting or sacrificing his or her desires and visions for the perceived desires and visions of the masses. Even when the race artist manages to maintain relative independence of vision, his or her work is overlaid with, and interpreted within, the social and political aspirations of blacks as a whole. Why? Because of the appalling lack of redeeming or non-stereotypical representations of black life that are permitted expression in our culture.

This situation makes it difficult for blacks to affirm the value of non-traditional or transgressive artistic expressions. Instead of viewing such cultural products through critical eyes—seeing the good *and* the bad, the productive *and* destructive aspects of such art—many blacks tend to simply dismiss such work with hypercritical disdain. A suffocating standard of "legitimate" art is thus produced by the limited public availability of complex black art. Either art is seen as redemptive because it uplifts black culture and shatters stereotypical thinking about blacks, or it is seen as bad because it reinforces negative perceptions of black culture.

That is too narrow a measure for the brilliance and variety of black art and cultural imagination. Black folk should surely pay attention to how black art is perceived in our culture. We must be mindful of the social conditions that shape perceptions of our cultural expressions and that stimulate the flourishing of one kind of art versus another. (After all, die-hard hip-hop fans have long criticized how gangsta rap is eagerly embraced by white record companies, while "roots" hip-hop is grossly underfinanced.)

But black culture is too broad and intricate—its artistic manifestations too unpredictable and challenging—for us to be obsessed with how white folk view our culture through the lens of our art. And black life is too differentiated by class, sexual identity, gender, region, and nationality to navel-gaze

about "negative" or "positive" representations of black culture. Black culture, like any culture, is good *and* bad, uplifting *and* depressing, edifying *and* stifling. All of these features should be represented in our art, should find resonant voicing in the heteroglossolalia of black cultural expressions.

Gangsta rappers are not the first to face the grueling double standards imposed on black artists. Throughout African-American history, creative personalities have sought to escape or enliven the roles of the race artist, with varying degrees of success. The sharp machismo with which many gangsta rappers reject this office grates on the nerves of many traditionalists. Many critics argue that since gangsta rap is often the only means by which many white Americans come into contact with black life, its pornographic representations and brutal stereotypes of black culture are especially harmful. The understandable but lamentable response of many critics is to condemn gangsta rap out of hand. They aim to suppress gangsta rap's troubling expressions, rather than critically engage its artists and the provocative issues they address.

The recent attempts by black figures like C. Delores Tucker and Dionne Warwick, as well as national and local lawmakers, to censor gangsta rap or to outlaw its sale to minors are surely misguided. When I testified on this issue before the United States Senate Subcommittee on Juvenile Justice and the Pennsylvania House of Representatives, I tried to make this point while acknowledging the need to responsibly confront gangsta rap's problems. Censorship of gangsta rap cannot begin to solve the problems of poor black youth. Nor will it effectively curtail their consumption of music, which is already circulated through dubbed tapes and without the benefit of significant air play.

A crucial distinction needs to be made between censorship of gangsta rap and the promotion of edifying expres-

sions of civic responsibility and community conscientiousness. The former seeks to prevent the sale of vulgar music that offends mainstream moral sensibilities by suppressing one's First Amendment rights. The latter is a more difficult, but rewarding task. It seeks to oppose the expression of misogynistic and sexist sentiments in hip-hop culture through protest and pamphleteering, through community activism, and through boycotts and consciousness raising.

But before we discard the genre, we should understand that gangsta rap often is able to rise above its ugliest, lowest common denominator. Misogyny, violence, materialism, and sexual transgression are not its exclusive domain. At its best, this music draws attention to complex dimensions of ghetto life ignored by many Americans. Of all the genres of hip-hop—from socially conscious rap to black-nationalist expressions, from pop to hardcore—gangsta rap has most aggressively narrated the pains and possibilities, the fantasies and fears, of poor black urban youth. Gangsta rap is situated in the violent climes of post-industrial Los Angeles and its bordering cities. It draws its metaphoric capital in part from the mix of myth and murder that gave the western frontier a dangerous appeal a century ago.

Gangsta rap is largely an indictment of mainstream and bourgeois black institutions by young people who do not find conventional methods of addressing personal and social calamity useful. The leaders of those institutions often castigate the excessive and romanticized violence of this music without trying to understand what precipitated its rise in the first place. In so doing, they drive a greater wedge between themselves and the youth they so desperately want to help.

More troubling, many of the most vocal black critics of gangsta rap fail to see how the alliances they forge with conservative white male politicians are plagued with problems. Many of the same conservative politicians who support the attack on gangsta rap also attack black women (from Lani Guinier to welfare mothers), affirmative action, and the

redrawing of voting districts to achieve parity for black voters. The war on gangsta rap diverts attention away from the more substantive threat posed to women and blacks by conservative white politicians. Gangsta rap's critics are keenly aware of the harmful effects that genre's misogyny can have on black teens. Ironically, such critics appear oblivious to how their rhetoric of absolute opposition to gangsta rap has been used to justify political attacks on poor black teens.

Sad, too, is the silence of most critics in the face of the vicious abuse of gay men and lesbians in gangsta rap. "Fag" and "dyke" are prominent terms in the genre's vocabulary of rage. Critics' failures to make this an issue only reinforce the inferior, invisible status of gay men and lesbians in mainstream and black cultural institutions. Homophobia, a vicious emotion and practice, links middle-class mainstream and black institutions to the vulgar expressions of gangsta rap.

Gangsta rap's greatest "sin" may be that it tells the truth about practices and beliefs that rappers hold in common with the mainstream and with the black elite. This music has embarrassed mainstream society and black bourgeois culture. It has also exposed our polite sexism and our disregard for gay men and lesbians. We should not continue to blame gangsta rap for ills that existed long before hip-hop uttered its first syllable. Above all, gangsta rap forces us to confront the problems and possibilities of transgression and the demands of racial representation that plague and provoke black artists.

Survival of the Artist in the New Political Climate

by Carol Becker

A res publica *stands in general for those bonds of association and mutual commitment which exist between people who are not joined together by ties of family or intimate association; it is the bond of a crowd, of a "people," of a polity, rather than the bonds of family or friends. As in Roman times, participation in the* res publica *today is most often a matter of going along, and the forums for this public life, like the city, are in a state of decay.* —Richard Sennett[1]

In my attempt to understand the present political climate and to locate the place and survival of the artist within it, I would like to begin in a Buddhist Temple in Chicago. I was talking with the director of the temple, the Venerable Samu Sunim, who wanted me to take note of an original brush painting by a famous Korean artist. Depicted in this painting was a bird perched on a branch, a rather sad and even motley creature with a strange, sly, and somewhat suspicious look in his eye. "You see that bird?" asked Sunim. "It is something like a vulture, a bird of prey. It is high up, removed from the world, like the artist who looks askance at the world, but not at the people."

I found this distinction significant, because in recent years artists have often confused the world with the people who inhabit it. They have frequently turned away mistrustfully from what they perceive to be the viewpoint of the masses, when in actuality it has been a fear of the repression of the prevailing ideology—often held in the hands of a few and *called* society— that has been anticipated. This seems symptomatic of a general confusion about the nature of society and where the individual stands in relationship to it—a serious conflation of public and private currently affecting the role of the artist and the role of the arts in the United States.

Artists are inevitably caught in such societal confusions because they are so often the ones who alchemize personal vision, give it shape, and place it, transformed, into the public arena. Artists also frequently take a public concern—such as homelessness, domestic violence, ecological disaster, or the AIDS virus—and work it through the self, demonstrate how it has affected them, and re-present it to the public, anticipating the debate it will encourage. It is often in this transition, transformation, and transubstantiation into matter, as artists attempt to move the idea or issue out from the self and connect it to society, that conflict arises. Performance artist Ron Athey was severely chastised when he performed a piece that dealt directly with being HIV positive, a work representing his attempt to take the anxiety of his personal condition and refor-

mulate it within the performative space as a social problem, a collective anxiety. This caused an unnerving effect, it aroused the audience's deep fears about contagion.

With externalization comes politicization. If Barbara DeGenevieve, for example, wants to make a statement about sexuality and middle-aged women and uses images of her own body and explicit statements about her own sexuality to do so, or if Andres Serrano goes into the public morgue and violates someone's sense of the appropriate way to confront death by photographing corpses that have entered into the public domain, then these artists are serving important functions: They are moving between the private and the public, taking from the public to examine the private, taking from the private to examine the public. While some have praised the sophistication of these efforts and their importance to a democratic exchange of ideas, far more have attacked them for making public—and therefore politicizing—that which society (for whatever reasons) wants to keep private.

Artists are caught without a real public forum within which to debate issues, even though such a forum is a basic tenet of democracy. Television *could* function as such a public space for debate, albeit electronic, but more often than not even the highly charged social issues presented on television are transformed, depoliticized into trivia or mere personal problems by the talk-show host or communal psychotherapeutic format that this medium has perfected. This creates merely an *illusion* of political debate. Intimacy, or the expectation that there will be intimacy in public life, has now completely submerged the political, and with it the sense of a public persona that functions in the public arena, just as Richard Sennett predicted 20 years ago when he wrote *The Fall of Public Man.*

Take, for example, the presidency of Bill Clinton: From day one his viability as President has been measured by his extramarital affairs, private investments, and Hillary. Evaluations of Clinton have rarely focused on his proposed political policies. If he loses the next election, it will have more to do with the per-

ception that he is indecisive and lacking in charisma than with what he actually has accomplished or tried to accomplish during his term in office. It seems that the presidency—the position itself—has lost respect; not because Clinton has done anything worse than Bush or Reagan, but because, for whatever reasons (his age, his liberal politics), Clinton appears more vulnerable to intense personal scrutiny. A friend of mine active in the labor movement is convinced that Clinton did himself a great disservice when, asked on television what type of underwear he wore—briefs or boxer shorts—he chose to answer. His presidency—the distance needed to maintain respect, if not for the individual, then for the office itself—had been violated by the question and his subsequent complicity in answering it.

The notion that the public sector should operate like the private one has enabled the media to ask these questions, to invade the public persona and assume an intimate connection to it. Yet the minute the distance is lost, the charisma is broken. The public sector is abandoned, and Americans resent it. Where are the serious public forums for debate that supposedly lie at the core of the democratic process? In the '60s we said, "The personal is political." Now we might say, "The political has become personal."

Another way of understanding this conflation of public and private is to note the increased emphasis on family values—first by Dan Quayle and the Republicans and now, in self-defense, by Clinton and Donna Shalala. Social malfunctioning in the society is too often blamed on the breakdown of the family. "If the family cared, if the family were intact, if the family set the right example, then there would be no crime, no need for abortion or gun laws, no disenfranchised youth, no teen pregnancy." It is as if the entire future of America rests with parents and the example they do or do not set for their children. How can we respond to this? Perhaps only with a series of questions: Has the breakdown of the family caused unemployment, racial discrimination, sexism, violence, the destruction of the educational system, the degenerating urban landscape, ecological disaster, or the

recession? Is there nothing within the public domain that might affect the family? An exploitative media industry, for example? Or the lies that have been told for the so-called public good—like the intrigues surrounding Watergate, Contragate, and the Gulf War? Do we blame the end of the American dream on the failure of the family? Or do we blame the degeneration of the family on the lack of healthy values in the dominant society? On racism, classism, the upheaval in gender roles? On the collective inability to generate a new image for this country now that the nineteenth-century dreams of manifest destiny or progress seem absurd and the United States' domestic failures to control drugs, crime, and internal terrorism have smashed its national innocence?

Because everything is personalized, there is little analysis of how society, as a larger social unit, has reached this point of decline. We know that in the '80s, while artists worried about their careers and intellectuals focused on publishing and tenure, arts education—in fact the *entire* public educational system in the United States—was decimated. But where were the massive public protests? In the '90s, education has become a class issue. If you can afford to send your children to private school they will get a decent education. If you cannot, they won't. What does this inequity do to the possibility of democracy?

If the '80s were characterized by a self-serving attitude that allowed many to pull away from more public roles, the '90s already seem different. This decade is about crossing-over, finding a public voice, perhaps in response to the feeling that since the public sector no longer educates America, *someone* must. In this sense the '90s have been a better time for artists—not financially, but spiritually. Having recognized the collapse of the art market, many artists are making a greater commitment to connect, to reach out, to ask serious questions about who constitutes a community, which communities one wants to be part of, and which communities one wants one's work to reach. It would

be wonderful if the gallery, performance, or design worlds could support artists economically, but there is now little illusion that the marketplace will ever sustain most artists' souls. There must be a connection to something larger. It is precisely when artists reach out and wrestle with difficult issues in the public sector in the hope of making a public statement, however, that they get in trouble with the greater society.

The current pressure to conform to one particular idea of family values and the inevitable distrust of the provocative and the Other is symptomatic of the hypocrisy at the core of the American Dream. These contradictions communicate that one should locate oneself in relationship to what is familiar, and safe, digging in one's heels and staying put. But what happened to the image of a diversified, multicultural society that was a major topic of discussion in the '80s? Why is this country positioned to retreat to the most basic unit of sameness—the family—as if there were no larger social units that could bring people together? Why is there no sense that community might come out of Difference, or that it might cross over differences? There is, at this moment, little popular discussion of reconciling Otherness, only of consolidating sameness. How can artists fit into this configuration when most are not interested in homogeneity, or keeping silent about important social issues which affect us all? Artists want to shake things up, reveal the contradictions, force people to re-see what they think they have already seen. Artists are not interested in fitting in.

Because government funding agencies have colluded with this pressure to make artists conform, serious problems arise for artists. Those organizations, like the National Endowment for the Arts, that have difficulty articulating the place of art in American society also seem unable to acknowledge the diversity at the core of this society. This has been a great disappointment to art communities. But this only clarifies the need for a reevaluation of what artists can actually expect in terms of federal support. It is essential, for example, that the NEA continue to give away at least 160 million dollars every year to worthy projects of individual

artists, community arts initiatives, and major arts institutions whose efforts they find acceptable. Money must continue to be allocated to fund community-based educational initiatives, even though there is pressure that the work produced not involve issues of sex, religion, race, class, gender, or death. Funds for the symphonies, operas, and museums are essential. However, it is clear that in the future there will probably be very little money for work that challenges the assumptions of what once might have been called "mainstream America." But instead of artists interpreting this as a personal rejection of their work, or as an attack against art in general, they need to understand it more objectively as an attack against representations of Difference and against the political impact of those who ask difficult questions and insist that art serve its function and create public loci for debate.

In order to protect artists from further humiliation and to make them into a viable political force, I propose the formation of a new organization; one composed of the at least 330,000 people who registered themselves on their tax forms as artists in the United States last year. This new organization, or Artists' Trust,[2] as it might be called, could function as a peer-funding body and also as a lobbying force. Artists, writers, and intellectuals could begin to fund each other until we reach a point as a society where the real value of art is finally recognized. Until that time, very successful artists—musicians, filmmakers, painters, writers—need to help subsidize those not yet successful, as Herb Alpert has done by creating five $50,000 grants to be given away each year to promising artists who have not yet received national recognition. If 330,000 artists become members (thus making them eligible for grants) at only $100 each, through peer-panel reviews we could begin to support individual artists and the important work that must continue to be made. While all this is going on, artists can use this organization to lobby, with a strong, unified voice, against the breakdown of the public educational system and the end of arts education in the public schools. If artists publicly speak out about these issues, which

directly affect them and the rest of society, people would see artists fighting for important values and might then be willing to join them in protecting those agencies which fund creative work. If there is only an art-illiterate public in this country, who will be the audience for art? Who will defend artists when controversies arise? How will young people even know they want to be artists if they never make art as children and don't know where to look for it as adults?

Art is fundamentally an exchange of ideas, which, although mostly conceived and executed in private, often cannot help but publicly expose society's inherent social contradictions. I say all this knowing that artists and writers are, as always, fighting for their lives, but the answer to the loneliness that we all feel is not in creating more isolation, or retreating into units of sameness, however different our versions of sameness may at first appear. Rather, the radical act is to take one's place in the public sphere, as an outspoken artist, a public intellectual, refusing the trend in American society to privatize and then internalize public issues. We need to establish public forums in which to join artists' concerns with other social concerns. This will allow us to begin creating a theoretical framework that will enable artists and intellectuals to reach outside themselves, to build a strong base, one that might actually cut across the class lines that increasingly divide North American society. The more artists understand why their work is often resisted, the more deliberate the strategy implicit in its execution will be. The more that artists accept the inherent social nature of their task, the more they can use their position and their strength to mobilize real political power. I have observed such a process in South Africa, where 180,000 artists formed the National Artists' Coalition. This organization has become the major legislative body for the arts in South Africa. I take heart from their struggle and success. We can look to them and learn how a truly independent mobilization of artists might be accomplished, and how influential it might become as it raises *the* significant issues within the public sphere.

notes

1 Richard Sennett, *The Fall of Public Man* (New York: Norton, 1974), pp. 3-4. 2 The name "Artists' Trust" was actually developed in discussions with Peter Taub, Director of Randolph Street Gallery, and Carlos Tortollero, Director of The Mexican Fine Arts Center Museum, after this talk was first presented.

Where Do We Go from Here?

Securing a Place for the Artist in Society

Michael Brenson

From its inception, *the National Endowment for the Arts has been a symbol and gauge of American artistic vision and nerve.*

When the Endowment was founded in 1965, American art gained a foothold at home and abroad it did not have before. When the Endowment was relatively confident and unconstrained, American artistic culture was essentially confident and unconstrained. In 1989, however, the political Right began closely monitoring the selections made by the Endowment's peer-panel process, using the work of gay and lesbian artists to stigmatize the Endowment, American artists, and, by implication, the entire enterprise of American art. Since that time, the Endowment has been on the defensive and artists have had trouble imagining the kind of ambition and sweep that have been almost synonymous with American art since World War II. My aim here is not to articulate and examine the many reasons why American art as a whole has been in a restless, fragmented, uncertain state, nor is it to deal directly with the question of whether the Endowment should continue to exist if it must constantly justify itself to the kinds of bigots who have always been the enemies of the creative imagination. My intention in focusing on the role of the Endowment during the last 30 years is to shed light on the current situation of American art and contribute to the conversation about artistic responsibility and necessity in the immediate future.

In order to convince you of the importance of the Endowment, I need to give you a personal sense of the New York art scene before it existed. I was born during World War II and grew up in Manhattan after the war ended. An impressive list could be put together of pre-World War II American painters. Arthur Dove, Thomas Eakins, Marsden Hartley, John Marin, and Georgia O'Keeffe would be on it. Winslow Homer is, to me, as good as any artist America has produced. But American Modernism only began to be widely appreciated after the war. When I was a child, art was very much on the periphery of American life, and American art was almost entirely unknown outside the United States. When I told my elementary-school classmates that my father was a painter, faces went blank. The idea of someone being a Modernist painter, not to speak of a painter committed, like many other artists whose lives had been ruptured

by the war, to spiritual abstraction, had little or no meaning for them. They did not judge me on my father's profession—they were my friends—they simply could not relate to it. Being a painter was far less real to them than being a garbage collector or a street sweeper; art was not even a profession, being an artist was like being a non-person. I don't know what my father thought about this. I do know he had no wish to assimilate himself entirely into America. He returned every summer to Paris, where he had lived between the wars, where as a child I saw him and other artists gather in cafés in the heart of the city and take for granted that Paris belonged to them as much as it belonged to anyone else.

In the aftermath of the war, the attitude toward Modern artists throughout American society was generally far more suspicious than it was among six- to eight-year-old big-city kids. Outside their own circles, artists, particularly those rooted in Modernism, were widely considered deadbeats or undesirables. They were identified with everything triumphant but edgy America was afraid of. What it was most afraid of, it seemed to me, were Communism and homosexuality. In those years, the radical, or experimental, or conspicuously non-traditional artist was identified with both. Somewhere near the nerve center of the American psyche, the artist, the Communist, and the homosexual were an unholy trio. I am not going to try to prove this link here, some of you will know what I am saying without my having to prove it. I am asking you to accept it as an experiential truth that I absorbed week-in, week-out, in the streets, in other public places, traveling with my mother or father. We were foreigners, and I knew this not just because my parents spoke, dressed, and thought differently from other parents I knew. (The rhetoric of Eurocentrism is unfortunate in its denial of the divide between American and European cultures, these cultures have never been and are not now the same, not even after the international conquests of Coca Cola, McDonalds, Levi's, and Hertz.)

The "foreignness" of my family had as much to do with my father's profession. Certainly my father had his friends, he went to the Eighth-Street Club every Friday night; The Museum

of Modern Art was not a museum for him, but a home. Elsewhere, however, he and his friends often drew looks and comments. They were suspicious, they were strange, they were Other. The link of the artist with foreignness, Communism, and homosexuality helps explain why the Abstract Expressionists made such a point of their barroom manner and macho swagger. In order to gain a new kind of respect for the artist in America, they had to make sure the artist was disassociated from Communism, homosexuality, and foreignness. The Abstract Expressionists thought deeply, and among them only Pollock was really uncomfortable with words, but some of them almost hid their intelligence. The image they cultivated—of the hard-drinking, non-verbal, apolitical male—was one with which postwar America could feel at ease. For the sake of American art at that time, the Abstract Expressionists *had* to do what they did. By offering an unmistakably and conventionally American image of themselves, and by producing paintings of radically unconventional beauty and imagination that other postwar artists, around the world, had to think about, they helped to create the basis for a postwar American art that American institutions could consider truly American. Abstract Expressionism, along with the Color Field painting, Pop Art, and Minimalism that followed, projected a scale, a newness, an inventiveness, and a conviction that the mass media could latch onto. So could a government Cold-War machine looking to spread the word about American creativity and values.

With the Kennedy Administration, institutional respect for the artist seemed to become formalized. In October 1963, a month before his assassination, President Kennedy gave a famous speech upon receiving an honorary degree at Amherst College, at the dedication of the Robert Frost Library, that promised to end forever the second-class status of the American artist. I don't think the formation and development of the National Endowment for the Arts and the National Endowment for the Humanities, and the crises these endowments are now experiencing, can be understood apart from it.

Kennedy began his speech by linking "art and the progress of the United States." He emphasized the need for a sense of "responsibility to the public interest." Then he defined the role and responsibility of the artist:

> *The men who create power make an indispensable contribution to the nation's greatness. . . . But the men who question power make a contribution just as indispensable.**

He also said:

> *When power leads man toward arrogance, poetry reminds him of his limitations. When power narrows the areas of man's concern, poetry reminds him of the richness and diversity of his existence. When power corrupts, poetry cleanses.*
>
> *For art establishes the basic human truths which must serve as the touchstones of our judgment. The artist, however faithful to his personal vision of reality, becomes the last champion of the individual mind and sensibility against an intrusive society and an officious state.*

And Kennedy said this:

> *If sometimes our great artists have been the most critical of our society it is because their sensitivity and their concern for justice, which must motivate any true artist, makes him aware that our nation falls short of its highest potential.*
>
> *I see little of more importance to the future of our country and our civilization than full recognition of the place of the artist. If art is to nourish the roots of our culture, society must set the artist free to follow his vision wherever it takes him.*

nnedy's speech was
lished in its entirety
he New York Times,
ber 27, 1963, p. 87.

I looked up this speech a year ago and am still amazed by it. I find its mixture of optimism and pessimism fascinating: A sense of the inevitability of self-interest and tragedy goes hand-

in-hand with a sense of obligation to fight for justice and hope. I am struck as well by Kennedy's belief in the artist as an outsider whose outsiderness is justified by his or her responsibility to the society of which he or she is always a part. After more than five years of political exploitation of Endowment grant selections by men like Senator Jesse Helms, Senator Alfonse d'Amato, Senator Robert Byrd, and the Reverend Donald Wildmon, I find almost painful Kennedy's belief that the artist supported by government also had to be protected from government if the artistic imagination in America were to be able to flourish. The conviction that art opposes power and that this opposition is cleansing—in other words, that art brings health to the body politic—is almost stupefying to me now, given the link made between the American artist and degeneracy by Pat Buchanan and others.

Government support for the arts after the Kennedy Administration made an enormous difference. There would not have been such an explosion of artists, dealers, collectors, critics, and curators if the government did not express confidence in art, if it did not feature art in its international programs, if it did not believe art was essential to the energy and purpose of the nation. The Endowments put a stamp of approval on American art and culture that encouraged new kinds of patronage and a level of institutional support they had not known before.

With all its party politics, and all its ups and downs, the National Endowment for the Arts did more than strengthen the fabric of artistic culture in America; it was proof that this fabric existed. If you look at the lists of grants awarded by the Visual Arts Program in recent years, you will find clear evidence of the Endowment's curiosity and openness and determination to recognize a diversity of talent and, in the process, to strengthen the diversity of artistic talent in the nation. Just as important, by giving grants to difficult art, challenging art, art that can offend or shock, it acknowledged that provocative and confrontational art is essential to the vitality of American art as a whole. You cannot have a thriving arts program, or any vital artistic culture for that matter, without supporting work that locates the fault lines of a

society and articulates feelings and thoughts that the society as a whole has avoided or been unwilling to face. At least since French Impressionism, art has proven its necessity by charting social, political, and philosophical currents and channeling them into images or events that coax or pressure people into becoming more aware of the tensions and possibilities within themselves and within the age in which they live. Through its responsiveness to all kinds of art-making, and through its willingness to fund art that pressures society to acknowledge that there is something at stake in art, and that artists as a group have something indispensable to say about the conflicts and longings of an age, the government sent a message that art mattered.

Then came 1989. This was the year that saw tirades on the floor of the Senate against government funding of exhibitions that included sadomasochistic and homoerotic photographs by Robert Mapplethorpe, and the infamous Andres Serrano photograph of a plastic crucifix submerged in the artist's urine. It continued in 1990 with right-wing attacks on grants awarded to the performance artists Karen Finley, John Fleck, Holly Hughes, and Tim Miller. Funding for Marlon Riggs's *Tongues Untied*, an eloquent and award-winning documentary about gay black men, drew fundamentalist fire in 1991. In 1994, a minuscule amount of Endowment money given by the Walker Art Center to another performance artist, Ron Athey, set the distortion machine of the Right in motion again. The Endowment now knows that the Right can exploit for its political purposes any grant it considers morally improper, and it knows that when the Right does single out a grant, the news media, as a whole, will jump through its hoops like trained dogs.

But the attacks of the Right do not, by themselves, explain why the Endowment is now so much on the defensive. I want to go back to Kennedy's speech for a minute. Its view of the artist is definitely that of the heroic outsider working on the periphery of a problematic society and state to help expose the truth about both.

In Kennedy's speech, the artist belongs to society but also doesn't, existing in a relationship between inside and outside that is extremely delicate, and inherently problematic to any political administration that does not share Kennedy's belief in the value of an outsider—a foreigner—helping to shape societal thinking about insider power. We live at a time when any view of the artist as a heroic outsider and any separation of artist and society are being severely challenged by the Left, and where the idea of the artist's moral authority is a joke to the Right. The Endowment would not be in trouble if some of the principles that led to its formation and development were not seriously contested, or dated.

But there is another crucial reason why the Endowment crisis occurred in 1989. Hand-in-hand with Kennedy's idealism was a hard realism. His view of art cannot be understood apart from the Soviet Union. He could be so free in advocating such a radical vision because that vision was perceived as a Cold-War weapon. By supporting such an enlightened view of the artist, Kennedy could contrast the approach to culture in the United States with the repressive state view of art in the Soviet Union. By showing the world he was so sure of his political system that he was not afraid of having it criticized by creative people distrustful of power, Kennedy could contrast the confidence of democracy to the insecurity of a government that did not tolerate criticism.

This link between cultural idealism and political realism, between commitment to the artist and Cold-War politics, has been, I am convinced, implicitly understood by succeeding administrations. It is this link, not respect for art, that convinced those administrations to uphold the ideals formulated in that 1963 speech. In the 1980s, the Reagan and Bush presidencies had almost no interest in art, and the ideological foundation supporting the government's commitment to American artistic culture got weaker and weaker. By the end of the decade, there was very little holding that commitment in place. When the Iron Curtain collapsed, the pragmatic need for a confident and unconstrained Endowment collapsed with it. The authority of the Endowment was suddenly and sharply diminished.

Institutional support for the arts on the highest political and corporate levels continues to shrink. What was most striking to me about Morley Safer's smug attack on contemporary art on "60 Minutes" in September 1993 was not its bread-and-butter philistinism, but rather the absence of any system to resist it.

The fall of the Iron Curtain had another effect on the perception of art in many parts of America. When Communism ceased to be the enemy of American values abroad, homosexuality became the main enemy at home. Three of the best artists whose aesthetic value Safer challenged are gay. By and large it is grants to gay artists that have drawn the sharks of the Right. The image of the gay or lesbian artist announcing, or flaunting, his or her views and fantasies unleashes the kind of hysteria that suspicion of Communists in institutional closets provoked after World War II. The old paranoia-inducing link between the artist, the homosexual, and the Communist is still very much alive.

What the events surrounding the Endowment during the last five years tell us is this: The artist has never gained as much of a foothold in this country as his or her economic success and star status during the last 30 years led many to believe. In many parts of America, the kind of hostility toward artists that so many people assumed had vanished is flourishing. Abstract Expressionists, Pop Artists, Minimalists, post-Minimalists, and many other postwar American artists have won big battles, but they have also left big issues unchallenged. Many other battles will have to be waged again and again and again. Like so many developments that once provided answers, the Endowment may now be as valuable for the problems it exposes as it is for the solutions it provides. The Endowment has done a great deal for American art and artists, but what it can do now is probably limited, and it must no longer be a symbol of American artistic vision and nerve.

How is the artist going to create a new support system? How do we take the next steps?

The new public art is crucial. By that I mean interactive,

activist art in the service of social change. This art is not made for art institutions and not defined by objects. It does not assume the in-your-face stance that provokes such predictable reactions by the Right, it functions outside the art market that fuels the Morley Safers of the world by generating so much cynicism and hype. It encourages conversations about issues rather than calling attention to itself. It works toward or realizes actual changes in the environment. It builds collaborations between artists and communities outside social and political power. This kind of art reflects the experience of our world expressed in Guillermo Gómez Peña's declaration that "We are living in a state of emergency." It is very much about infrastructure; it works on a grassroots level to listen and mobilize and construct a kind of foundation for art that powerful art institutions cannot now build. This kind of art, some of the best of which has been supported by the Endowment, exists in streets, in schools, in parks, in churches, in rivers, and on hills. It is directed toward audiences that art institutions have barely reached even on those occasions when they have been interested in them. No other art can now have a more decisive effect on the awakening of consciousness and hope.

To this point, much of this public art has been serving communities at risk, which have been pretty much defined as minority communities, in urban centers, with roots in non-Western cultures. I want to emphasize the need for more of these artists, many of whom come from the working class, to approach precisely those communities that support Helms, Byrd, and Buchanan; those communities that continue to link Modern artists, homosexuals, and Communists as the enemy. Since the beginning of Modernism, these communities, more than any others, have been perceived as the enemies of art. Within the art world now, these segments of white middle- and lower-middle-class America that made up Baudelaire's "vulgar herd" are the demonized Other. It cannot be surprising, therefore, that they are really the enemies of unconventional and innovative art. In order to diminish their fears about art and artists, it is going to be necessary to see the humanity of people who may be anti-abortion, anti-environ-

ment, anti-gay, anti-Latino, and anti-black. It will also be necessary to end the rhetoric about white people, white men and Europeans, that has helped make many people stigmatized by that rhetoric wary of any notion of progress. The ease with which many so-called progressives indulge such stereotypes contributes to the ease with which the demagogues of the Right convince white people who feel beleaguered to jump on their bandwagons. Can we really change this country and establish a secure place for the artist in society without being shaped by and shaping the needs and humanity of the people on whom demagogues feed?

I want to end with a word to art students who are comfortable with institutions and interested in being painters or sculptors. If that is what you are passionate about, then no artistic bandwagon should make you turn your back on it. Object-making is essential, even now, certainly now. Painting and sculpture will always be irreplaceable. No one kind of art can ever be enough to satisfy all the needs that art must address. People in galleries and museums will always be looking for a kind of experience they cannot find anyplace else. You have far more room to maneuver now than you might think. It is important to consider what you can do in painting or sculpture that artists working in other media can't. It may not be possible anymore to believe that by changing language you can change the world, but that does not mean the language of painting and sculpture should not be thought about and reinvented so it can continue to move and inspire, and not simply become a journalistic way of expressing opinions and ideas. To you, I offer this unsolicited advice: Don't talk to your audiences, touch them; don't demonize Modernism, understand its richness and complexity; distrust either/or thinking; be generous, be generous; leave yourself exposed.

A version of this essay was published in pamphlet form by SAIC Press as *Where Do We Go From Here? The NEA Crisis and the Role of the Artist."*

Afterword

To-ing and Fro-ing Toward The Millennium

"The Artist in Society" was a conference about endings and beginnings. As we wound our way toward the end of the meetings, with all of their richness and controversy, we were just as surely, albeit a bit more slowly, slouching toward the millennium. As we went from this place into the waning hours of this century, we affirmed that it *is* the arts that will lead us, it is to the arts that we entrust our tenuous futures, and it is to the arts that we pledge our energies, our creative intelligence, and, if you will, our faith.

How is it that we, as artists, can sketch the landscape of 2001, can find anchors in the stormy seas on both sides of the Atlantic, can find the language and the images and the *space* to do our given work in the museums and galleries and foundations and government offices that frame the boundaries of our ideals with sometimes harsh realities?

We can, I think, because art is our last best hope. Not because artists are especially talented, or even because we are visionary, but because we are, by definition, skilled at crossing the semi-permeable barriers between whatever we might characterize as collective realities and their individual expressions as they exist in the particularities of our lives. Our task at this *fin de siècle* moment is to locate and name that relation, to challenge the late-twentieth-century legacies of individualism, isolationism, and spiritual anomie with the rich possibilities of a twenty-first-century dynamic affirming the fluid bond between the nurturance of the individual and the enrichment of the community as a whole.

I take my title from Tomás Ybarra-Frausto's remarks at the 1991 American Association of Museum Directors conference in Chicago. Tomás is Associate Director for the Arts and Humanities at the Rockefeller Foundation in New York, and thus knows intimately what "To-ing and Fro-ing" means, the necessity of it, the cost of it, and the value of it. This is Tomás speaking to all of us:

The fact is that artists are able to instinctively go back and forth between different landscapes of symbols, values, structures and styles and/or operate within a third landscape that encompasses both concurrently, To-ing and Fro-ing between multiple aesthetic repertoires and venues, both mainstream and community—museums, collectors, galleries and (new) alternative community infrastructures—artists question and subvert notions of cultural coherence and fixity. Contemporary revisions of identity and culture affirm that both are open, and offer the possibility of making and remaking your self from within a living, changing tradition.

This, among other things, is what artists do. It's what has been referred to as "simultaneous textuality," in which the boundaries of historicity, as we have known them, disappear.

Our to-ing and fro-ing conference brought together writers and critics, video artists and filmmakers, photographers and poets and painters, novelists and playwrights. We also brought art historians, philosophers, political activists, anthropologists and sociologists, foundation officers, an occasional theologian, and inevitably, an ubiquitous handful of lawyers. Participants came from Chicago, of course, but also from New York, Washington, and Los Angeles. They came from Krakow and Prague, South Africa and North Carolina, Mexico and Bombay, Cuba, Nigeria, and Iran. They came from The Glasgow College of Art and from Sussex University, and London sent an artist and a scientist. They were Muslims and Buddhists, Yorubas and Lakotas, Christians and Jews, atheists and agnostics. It was quite a gathering. And as much as the participants themselves shaped the agenda, we did articulate three major issues of particular interest for us today:

1) What mutual responsibilities bind artists to the societies that produce them and inform their work?

2) A related question: Can artists and art institutions responsibly shape their goals, their programs, their artistic production, to fit paradigms constructed by governmental bodies, corporations, and foundations seeking to play a leadership role in setting agendas for social change?

3) How can artists draw upon their capacities to imagine the future and create new work that helps make visible—and apprehensible—what I call the "bridging realities" that will illuminate new cultural meanings?

There was clear consensus that this agenda means acknowledging

multiple perspectives, new narratives of power, new taxonomies, and new technologies which broaden the parlance of cultural literacy to affirm an ever-widening spectrum of forms. Effectively, we tried to ask the questions necessary to embark upon what might be called a post-Postmodernist enterprise, or more precisely, a millennial enterprise.

Engaging the issues head-on, the artists at our conference emerged undaunted, affirming that the recognition of ethical and moral imperatives is not to be equated with soft-headed moralizing. What these artists were attempting to do was to replace the outworn notion of artist as marginal iconoclast with the declaration of artist as citizen. A very civilized enterprise, when artists agree to take seriously their responsibilities to serve as catalysts for social change. A new paradigm indeed, but one rooted in our oldest understandings of what it means to be civilized.

What we accomplished, I think, was connotational risk: we located *civilization* as a mode by which human beings can live together, a structure of community and of mutual responsibility approximate to what might also be termed *cohabitation,* living *with* versus merely coexisting. I like to think that our Chicago conference brought us together as artists and thinkers to figure out collective—and individual—responsible ways of doing the very work that we have been given to do. I hope we will continue to have the courage to frame the discourse not only in terms of economic impact, but in artist's terms, civilized terms, terms not of retreat and rampant privatism, but terms that affirm the power of the arts to build mutual respect, cultural literacy, community. I hope that as artists we can subscribe to a public contract that eschews the bottom line and straight, clearly delineated path in favor of the difficult but exciting challenge of to-ing and fro-ing. As bearers of the code, we are guardians of our past histories; as artists, we owe our best creative efforts to the future.

Ronne Hartfield
Executive Director, Museum Education
The Art Institute of Chicago

"1965 - 1975: Reconsidering the Object of Art"
October 15, 1995 — February 4, 1996

"Images of an Era: Selections from
the Permanent Collection"
October 15, 1995 — July 28, 1996

THE MUSEUM OF CONTEMPORARY ART · MOCA at the Temporary Contemporary
152 North Central Avenue, Downtown Los Angeles in Little Tokyo · tel: 213/626-6222

THE REOPENING CELEBRATION OF MOCA AT THE TEMPORARY CONTEMPORARY
IS SPONSORED BY PHILIP MORRIS COMPANIES INC.

STUDY IN THE SETTING OF A PREEMINENT ART SCHOOL

AND WORLD-CLASS MUSEUM ▲▲▲▲▲▲▲▲▲▲▲▲▲▲▲▲

BACHELOR OF **Fine Arts**

BACHELOR OF **Interior Architecture**

MASTER OF **Fine Arts**

MASTER OF ARTS IN **Art Education**

MASTER OF ARTS IN **Art Therapy**

MASTER OF ARTS IN **Arts Administration**

MASTER OF ARTS IN **Modern Art History, Theory, and Criticism**

MASTER OF SCIENCE IN **Historic Preservation**

TheSchool
The Art Institute of Chicago

For further information:
call 312. 899-5219 or 800. 232-7242
Admissions
The School of the Art Institute of Chicago
37 South Wabash Avenue
Chicago, Illinois 60603

Ohio Valley

Artists

Shaped by

Lore and

Landscape

**Aronoff Center Inaugural
Exhibition at the Alice F. and
Harris K. Weston Art Gallery
650 Walnut St.
Cincinnati, Ohio, 45202
(513) 241-3344**

THE RIVER

Curated by

David T. Johnson, Taft Museum
John Wilson, Cincinnati Art
Museum

JAY BOLOTIN:

Objects from
Organized by

the Mechanical Opera
The Contemporary Arts Center

Oct. 16, 1995 - Jan. 7, 1996

Tues - Sat	11 a.m. - 6 p.m.,
	until 9:30 p.m. on performance days
Sun	1 p.m. - 7 p.m. on performance days

Indulge your eye for art.

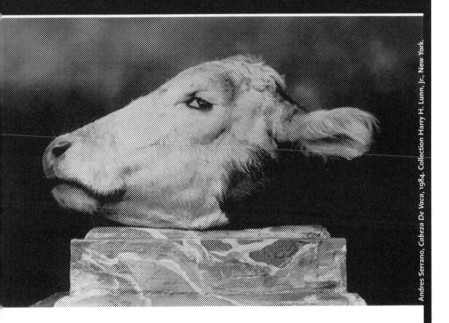

Andres Serrano is just one of the provocative artists you'll find at the MCA.

And on July 2, 1996, join us for the long–anticipated opening of the MCA's new building on Chicago Avenue, featuring an exciting exhibition schedule, the permanent collection, and more.

Don't miss:

Beyond Belief:
Recent Art from East Central Europe
Through November 26, 1995

Andres Serrano: Works 1983–1993
December 9, 1995 to February 4, 1996

Museum of Contemporary Art

237 East Ontario Street, Chicago

Call 312.280.5167 now for information about special charter membership benefits.

**Master of
Arts in
Curatorial
Studies**

**Center
for
Curatorial
Studies**

**Bard
College**

The Center for Curatorial Studies at Bard College offers an innovative, interdisciplinary graduate program in the curating of contemporary art. The two-year program, leading to an M.A. degree in curatorial studies, provides practical training in a museum setting as well as intensive study of the history, theory, and criticism of the contemporary visual arts and the institutions and practices of exhibition.

For further information, please write, phone, or fax the Center for Curatorial Studies.

Center for
Curatorial Studies
Bard College
Annandale-on-Hudson
New York 12504-5000

**Telephone:
914-758-7598
Fax:
914-758-2442**

The Museum of Contemporary Photography
Columbia College Chicago

The Museum of Contemporary Photography is a stimulating and innovative forum for the creation, collection, and examination of photographically related images, objects, and ideas. The museum collaborates with artists, photographers, communities, and institutions locally, nationally, and internationally. By presenting projects and exhibitions that embrace a wide range of contemporary aesthetics and technologies, the museum promotes a greater understanding of and appreciation for the cultural, social, and political implications of the image in our world today.

Targeting images, objects + ideas

600 South Michigan Avenue, Chicago, Illinois 60605
Phone 312.663.5554 Fax 312.360.1656

Denise Miller-Clark, Director
Ellen Ushioka, Assistant Director

Accredited by the American Association of Museums

anderson gallery

School of the Arts
Virginia Commonwealth University
907 1/2 West Franklin Street
PO Box 842514
Richmond, VA 23284 — 2519

804.828.1522

Santa Fe Art Institute

Recent Master Artists

Gregory Amenoff Larry Bell Lynda Benglis
John Chamberlain Eric Fischl Paul Jenkins
Donald Lipski Elizabeth Murray Beverly Pepper
Susan Rothenberg Charles Ross

The Santa Fe Art Institute offers a year round program of small, advanced Master Classes in painting, printmaking and sculpture with recognized Master Artists.

Not a traditional degree program. Acceptance based upon portfolio review. Scholarships and fellowships available.

P.O. Box 4607 Santa Fe New Mexico 87502-4607 **505 983 6157**

In 1996, the
Santa Barbara Contemporary Arts Forum
celebrates its 20th Anniversary as an arena for the presentation, documentation and support of a broad variety of visual, media and performing arts.

653 Paseo Nuevo
Santa Barbara, Ca. 93101
Phone: (805) 966-5373
Fax: (805) 962-1421

Home Show (*and Home Show II in 1996*)
Thrift Store Paintings
Terry Allen
Vito Acconci
Rachel Rosenthal
Addictions
Michele Blondel
Antenna Theater
Los Angeles Poverty Department
Masami Teraoka
John Baldessari
Ann Hamilton
Counterweight: Alienation, Assimilation, Resistance
Joan Snyder
Carl Cheng / John Doe Co.
William T. Wiley
In Terms of Time
Joan Tanner
among many others.

307

WITHDRAWN